THE BEST OF
Acrylic Painting

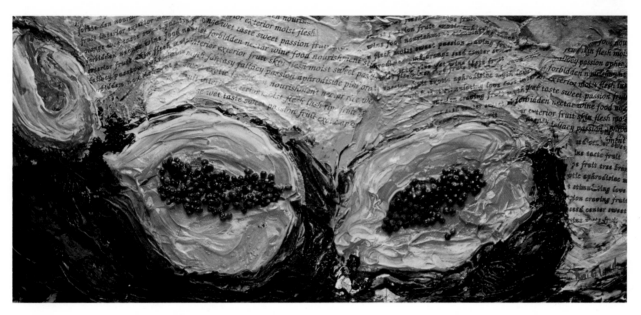

First published in the United States of America by:
Quarry Books, an imprint of
Rockport Publishers, Inc.
146 Granite Street
Rockport, Massachusetts 01966-1299
Telephone: (508) 546-9590
Fax: (508) 546-7141

Distributed to the book trade and art trade in the United States by:
North Light, an imprint of
F & W Publications
1507 Dana Avenue
Cincinnati, Ohio 45207
Telephone: 800-289-0963

Other Distribution by:
Rockport Publishers
Rockport, Massachusetts 01966-1299

ISBN 1-56496-268-7

10 9 8 7 6 5 4 3 2 1

Art Director: **Lynne Havighurst**
Designer: **Sara Day Graphic Design**
Cover Images: Front cover *(left to right):* p. 42, p. 52, p. 97
　　　　　　　Front cover *(background):* p. 111
　　　　　　　Back cover *(left to right):* p. 109, p. 372, p. 104

Printed by Welpac, Singapore.

THE BEST OF
Acrylic Painting

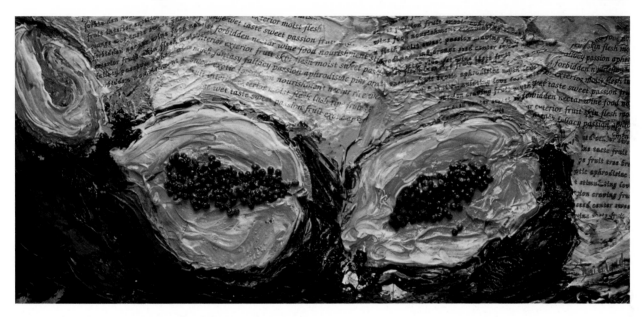

JURIED BY ALFRED M. DUCA AND LYNN LOSCUTOFF

QUARRY BOOKS • ROCKPORT, MASSACHUSETTS
Distributed By North Light Books, Cincinnati, Ohio

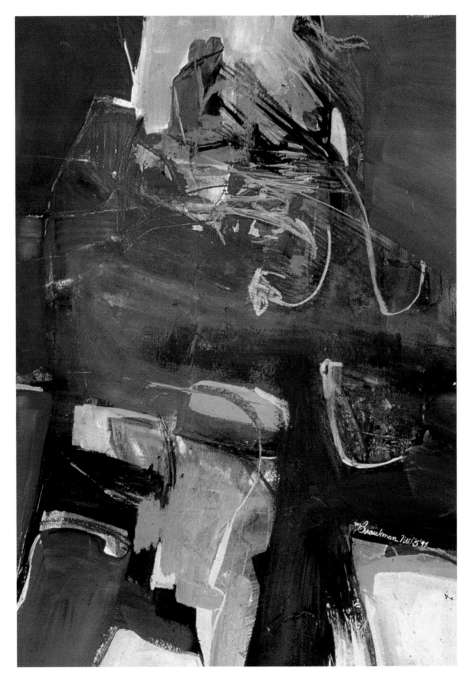

Mary Alice Braukman
Mythical Friends
22" x 30" (56 cm x 76 cm)
Acrylic with crayon and pastel
T.H. Saunders Waterford 300 lb. hot press paper

Introduction

Judging works of art has been a recurring dilemma for me. In the past, whenever I was jurying children's art work, I would always manage to give each one a prize. On one occasion, they all got first prize!

We jurors were asked to reduce several hundred submissions to a selection of two hundred. We weren't giving out prizes, but perhaps even better, the sponsors of this event, Rockport Publishers, were providing international recognition for being among the best of acrylic painters.

It wasn't easy. It was a stunning and rewarding experience and dramatically so, for though I am also a painter, this review was especially meaningful for me. I had pioneered, developed and marketed the first polymer emulsion nearly fifty years ago. It was called "Polymer tempera" back then, and was the forerunner to the now acrylic paints. What goes around comes around.

Because of my involvement with polymer and acrylics, it was critical that I shed all paternalistic tendencies and look at this newest wave of acrylic painters with bright eyes.

During an early break, my mind wandered off to a time when I was touring a group of art class kids through an exhibition at the Museum of Fine Arts in Boston. One of them, a 12-year-old, stopped in front of a Paul Klee painting and howled, "Hey guys, c'mere, look at this...pretty good for a kid, huh!?!"

Refreshed by this memory and its poignant meaning, I realized I had no reason to be astonished by the rich diversity of the works we were looking at. Four years ago, I had passionately lectured, written and extolled the virtue of the new process. Summed up in an article for the Polymer Era to come, I wrote, "Are painters willing to continue their careers within the scope of conventional practices or grasp the use of a new technology, capable of a much wider range of effects without the time-consuming, restrictive procedures of traditional techniques?"

It is said that a good teacher is a good student. I had a refresher course reviewing these paintings: like trying to get a drink from a fire hydrant...

—Alfred M. Duca

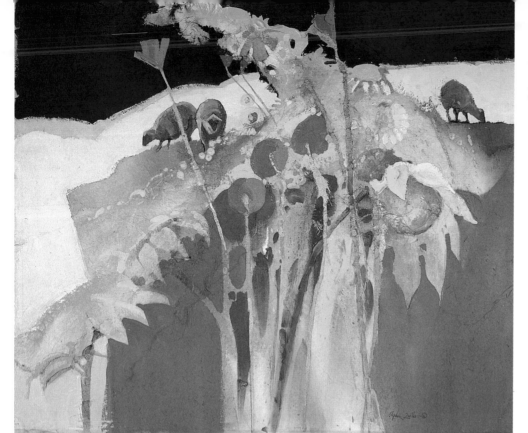

Stephen Quiller
Poppies, Sunflowers, and Sheep
26" x 32" (66 cm x 81 cm)
Crescent #5112 watercolor board

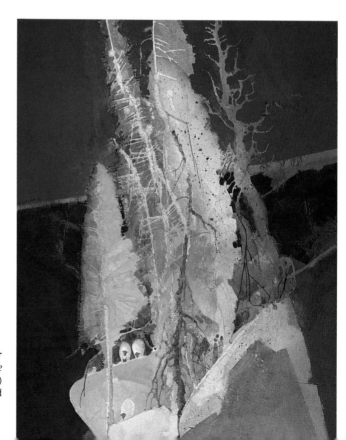

Stephen Quiller
The Twisted Spruce
32" x 24" (81 cm x 61 cm)
Crescent watercolor board

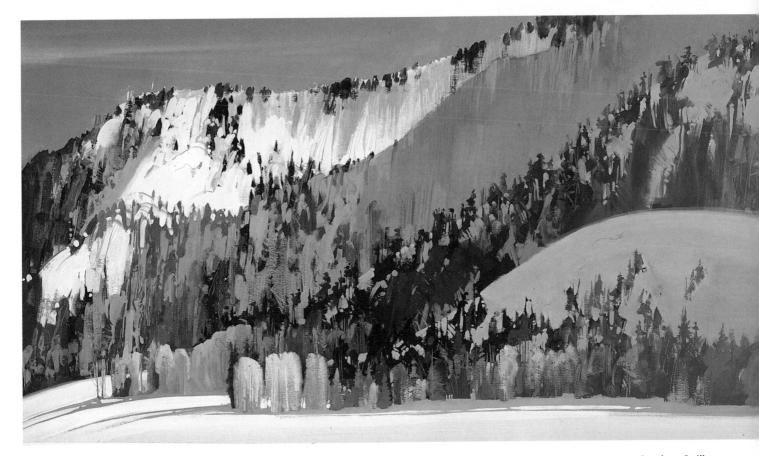

Stephen Quiller
March Light, San Juans
23" x 35" (59 cm x 90 cm)
Crescent watercolor board

Stephen Quiller
Beaver Pond, Deer Horn Park
23" x 34" (58 cm x 86 cm)
Crescent #5112 watercolor board

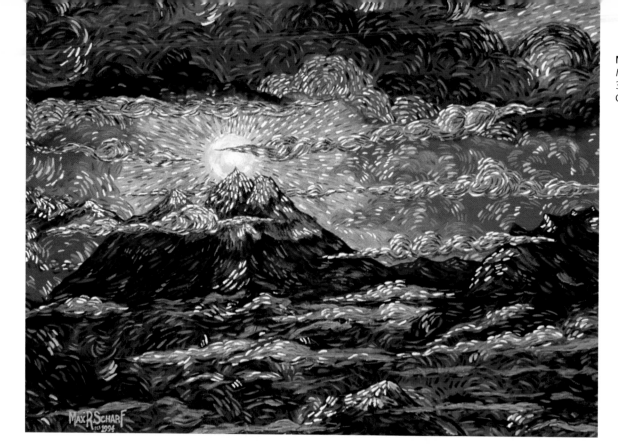

Max R. Scharf
In the Beginning...Life
30" x 40" (76 cm x 102 cm)
Canvas

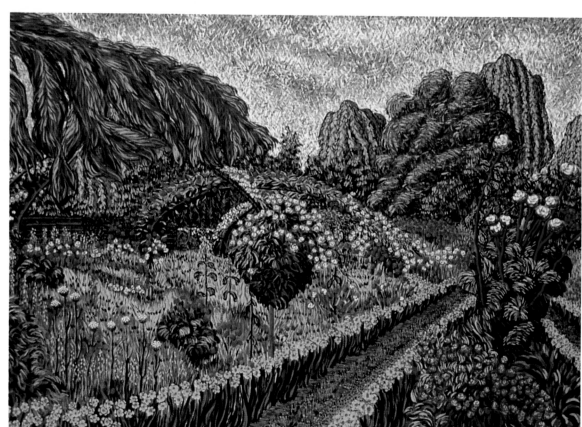

Max R. Scharf
The Gardens at Giverny
30" x 40" (76 cm x 102 cm)
Canvas

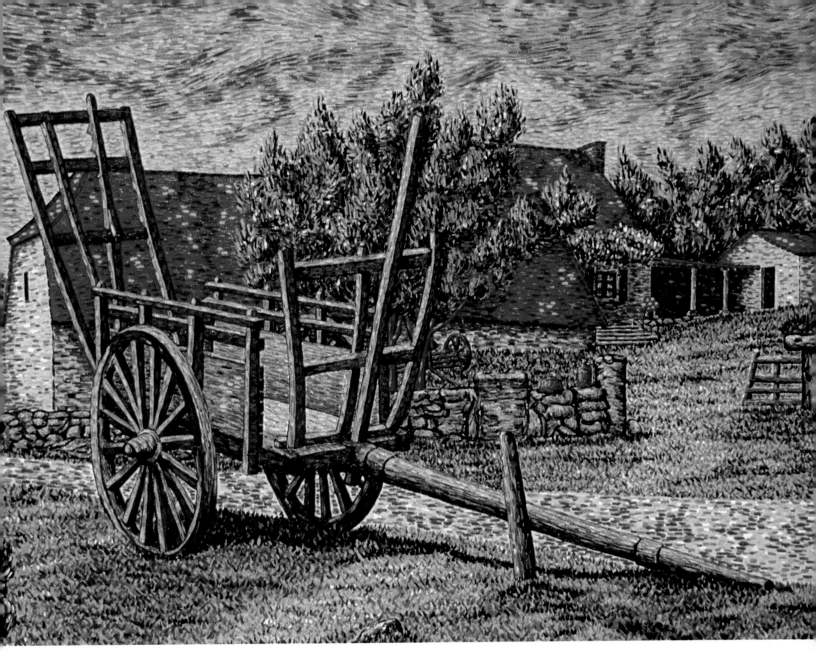

Max R. Scharf
Musee de Plein Air
30" x 40" (76 cm x 102 cm)
Canvas

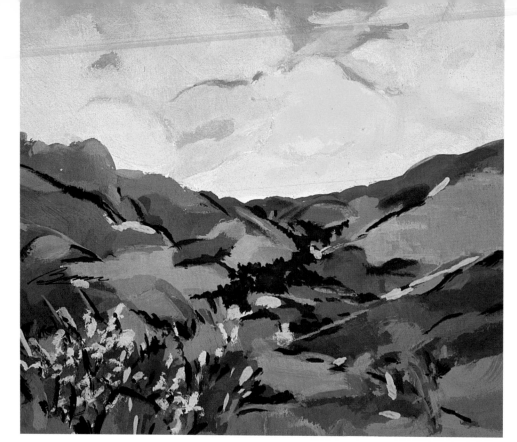

Jann T. Bass
Embudo
7" x 8" (18 cm x 20 cm)
140 lb. Hot press 100% rag watercolor paper

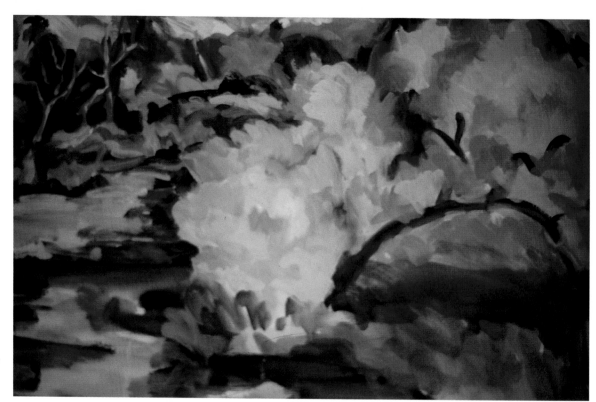

Janet C. Blagdon
Riverbend
22" x 29" (56 cm x 74 cm)
Arches 140 lb. watercolor paper

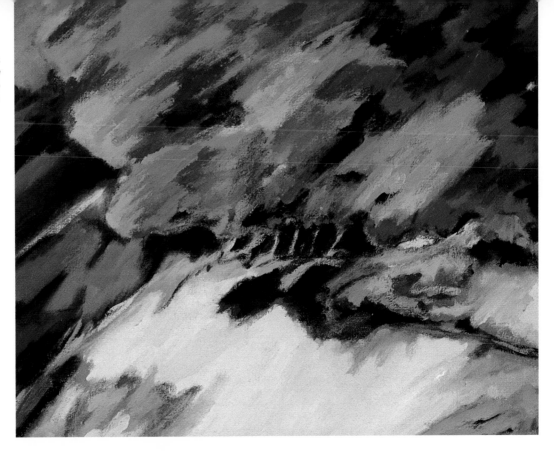

Elsie K. Harris
Reawakening
20" x 24" (51 cm x 61 cm)
Linen

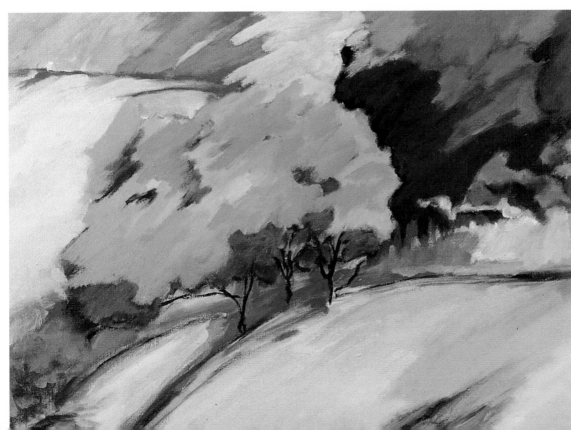

Elsie K. Harris
After Glow
24" x 31" (61 cm x 79 cm)
Linen

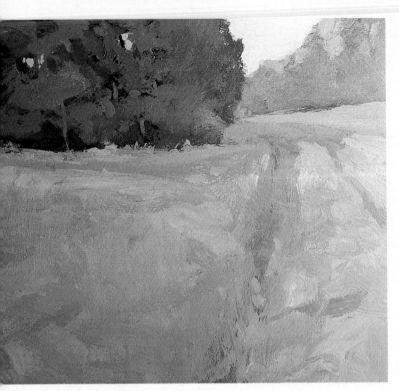

Bill Teitsworth
Lutz Farm
10" x 11.5" (25 cm x 29 cm)
Masonite board

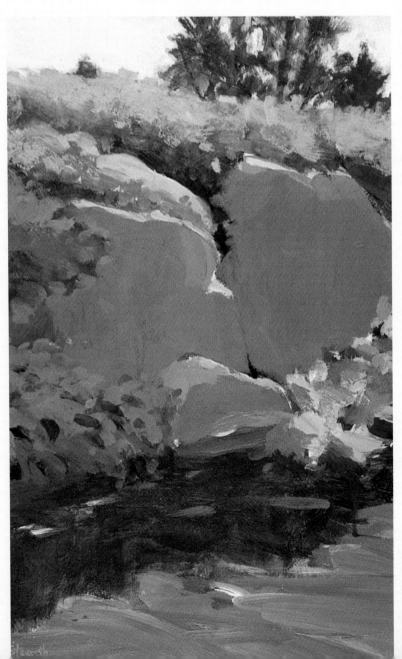

Bill Teitsworth
Quarry
18" x 11" (46 cm x 28 cm)
Masonite board

Bill Teitsworth
Heron Moon
20" x 18"
(51 cm x 46 cm)
Masonite board

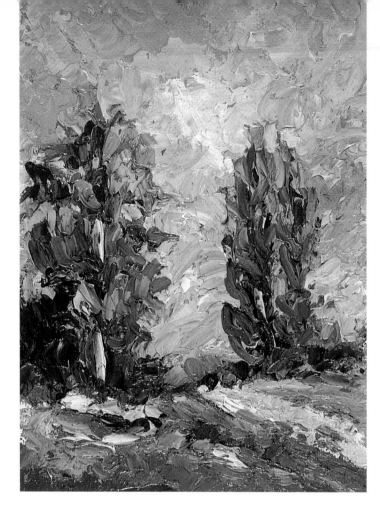

Valentina Landin
Twin Trees
7" x 5" (18 cm x 13 cm)
Canvas

Lloyd Bakan
Spring
24" x 30" (61 cm x 76 cm)
Canvas

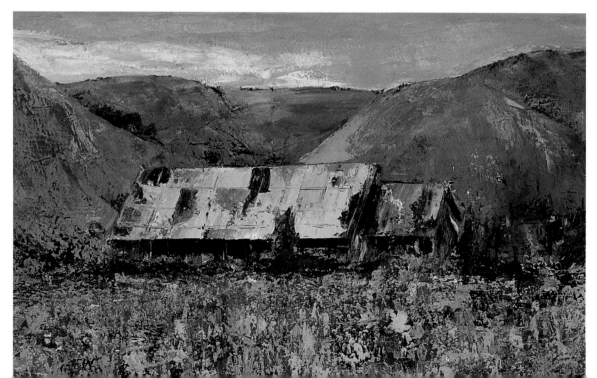

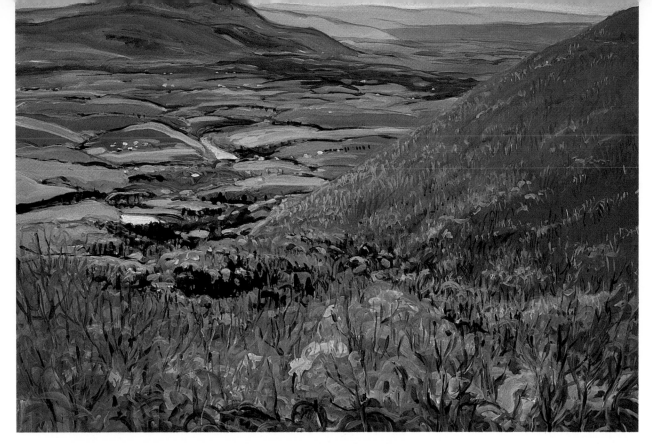

Carol Lopatin
Shenandoah Valley
29" x 41" (74 cm x 104 cm)
Arches 555 lb. cold press watercolor paper

Carol Lopatin
Davis Mountains High Pastures
29" x 41" (74 cm x 104 cm)
Arches 555 lb. cold press watercolor paper

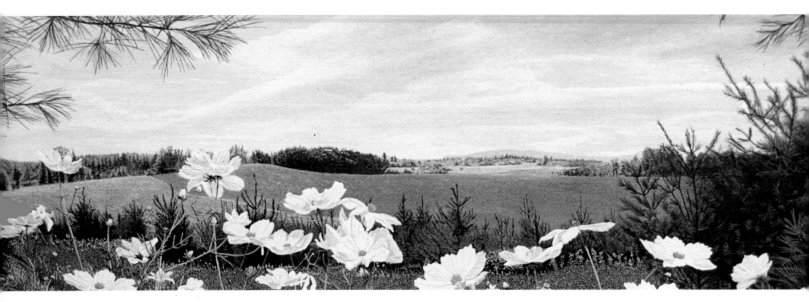

Tim Flanagan
Dance of the Cosmos
10" x 30" (25 cm x 75 cm)
Canvas

Michael R. Canter
A Walk
20" x 30" (48 cm x 72 cm)
Stretched canvas

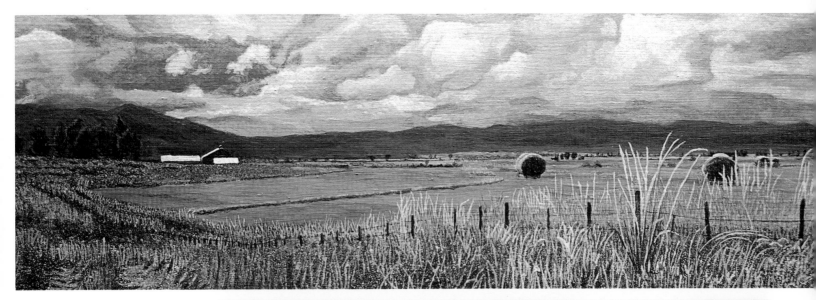

Tim Flanagan
Autumn Interlude
4" x 12" (10 cm x 30 cm)
Masonite panel

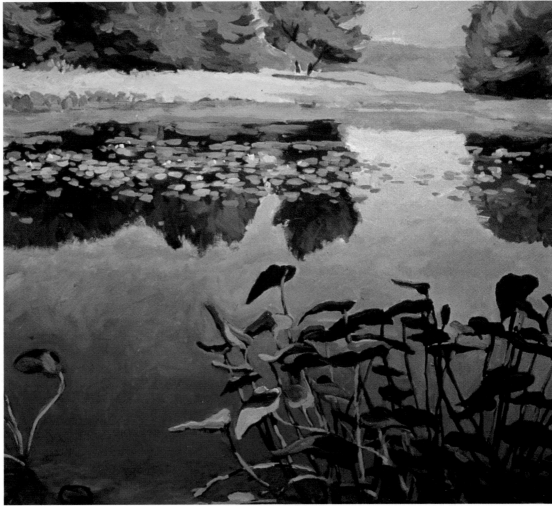

Kathleen McDonough
Pond with Water Lilies
44" x 52" (112 cm x 132 cm)
Canvas

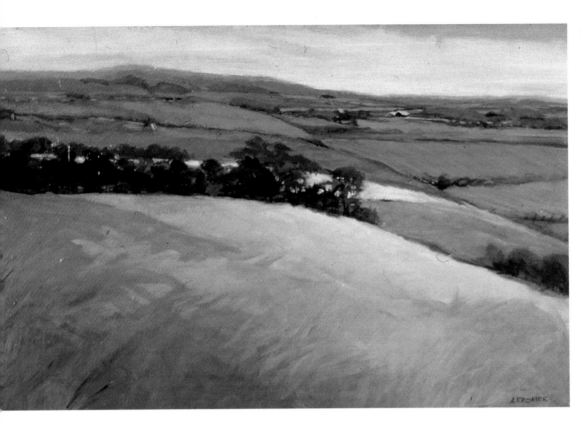

Ann Kromer
Homespun
24" x 36" (61 cm x 91 cm)
Canvas

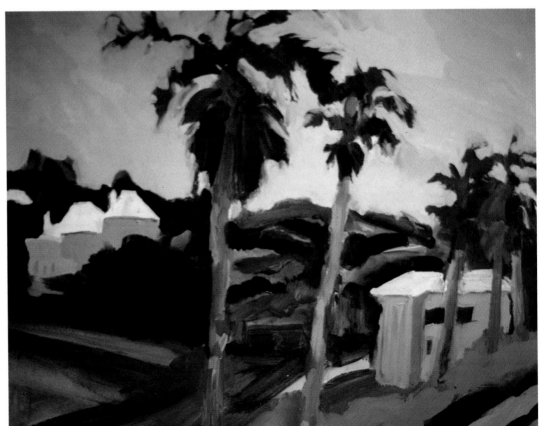

Janet C. Blagdon
Island Plantation
19" x 20" (48 cm x 51 cm)
Arches 140 lb. watercolor paper

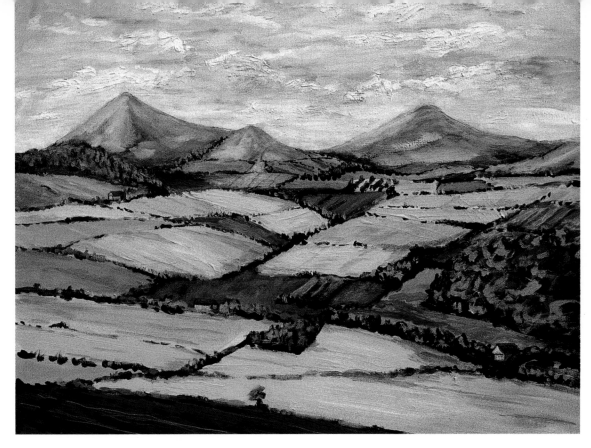

Petr Liska
Bohemian Highlands
24" x 30" (61 cm x 76 cm)
Canvas

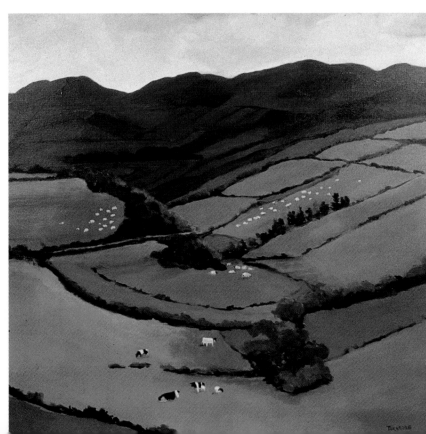

Lynn Tornberg
Irish Green
37" x 37" (94 cm x 94 cm)
Canvas

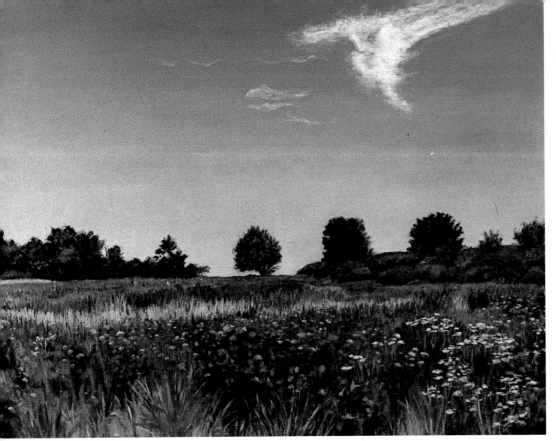

Marcia C. Wilhelm
Bay Farm Summer
11" x 14" (28 cm x 36 cm)
Hot press medium weight illustration board

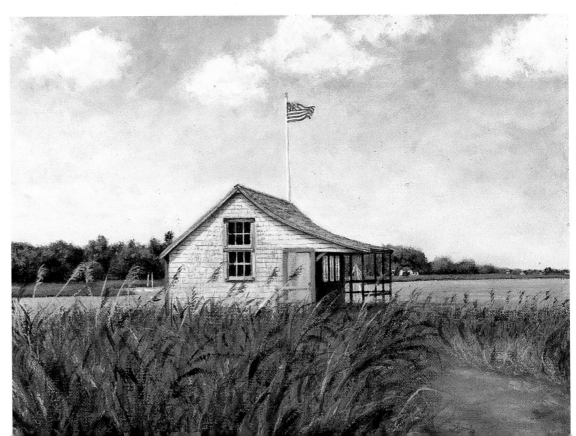

Marcia C. Wilhelm
Boathouse #2
9" x 12" (23 cm x 30 cm)
Canvas board

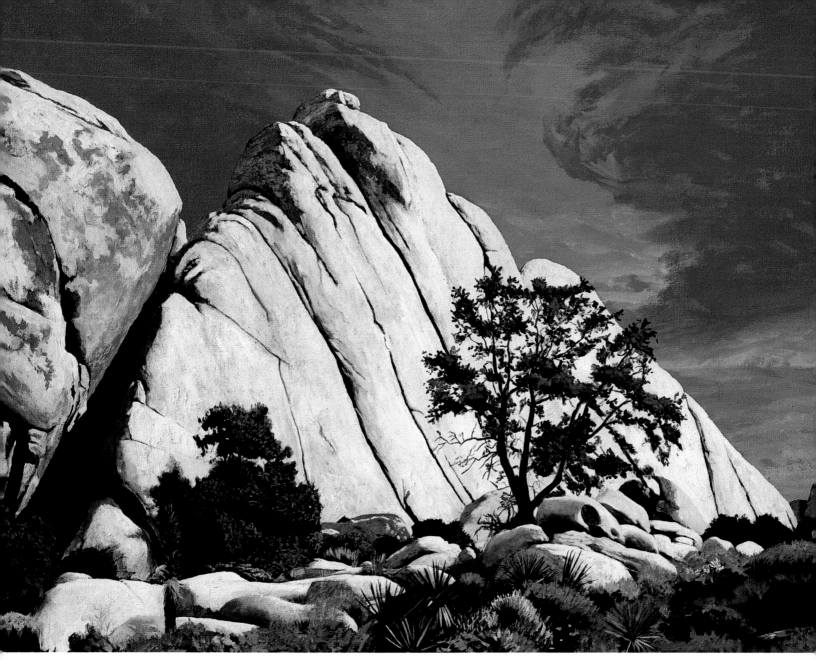

Lawrence Wallin
Hidden Valley
36" x 48" (91 cm x 122 cm)
Canvas

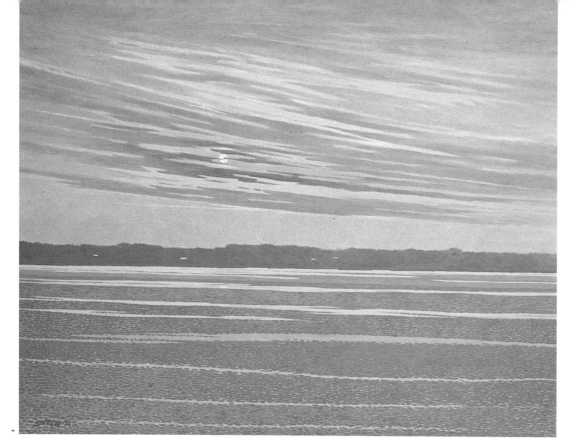

Rolland Golden
West of East Falmouth
32" x 40" (81 cm x 102 cm)
Canvas

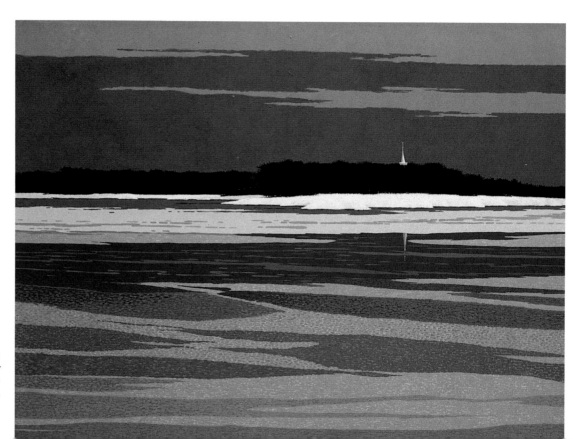

Rolland Golden
Wintry
32" x 40" (81 cm x 102 cm)
Canvas

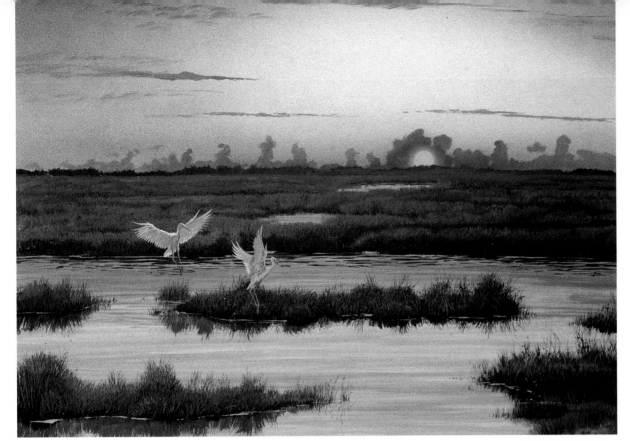

Steven L. Babecki
Last Flight
27" x 37" (69 cm x 94 cm)
Strathmore #112 cold press
watercolor board

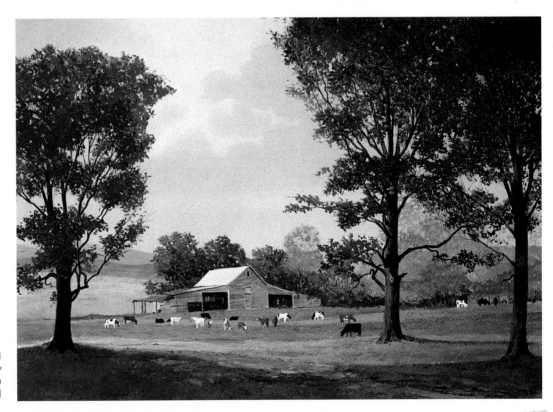

Steven L. Babecki
Ocala Country
29" x 39" (74 cm x 99 cm)
Strathmore #112 cold press watercolor board

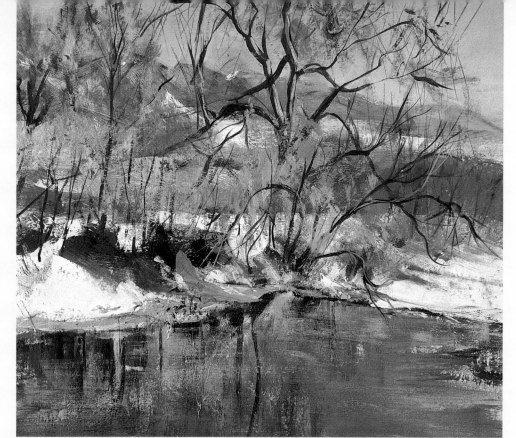

Judith Scott
Winterscape
20" x 24" (51 cm x 61 cm)
Hot press illustration board

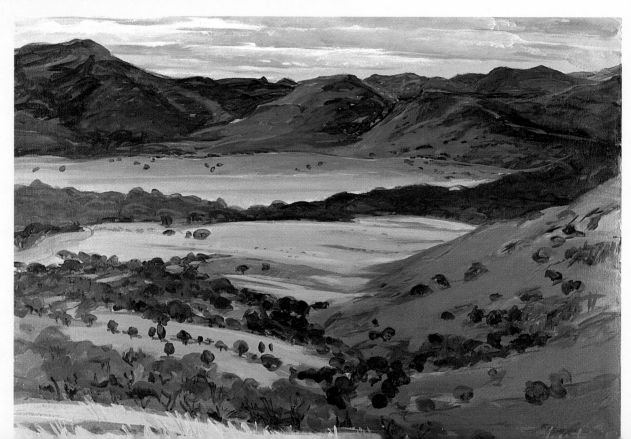

Carol Lopatin
Davis Mountains Voladera
29" x 41" (74 cm x 104 cm)
Arches 555 lb. cold press
watercolor paper

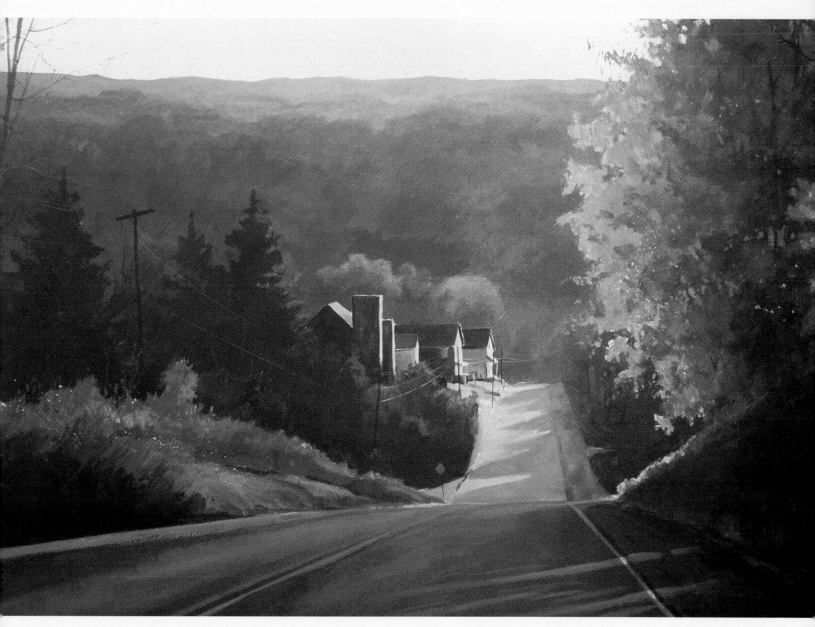

Christopher Leeper
Volant
22" x 30" (56 cm x 76 cm)
Arches 140 lb. cold press watercolor paper

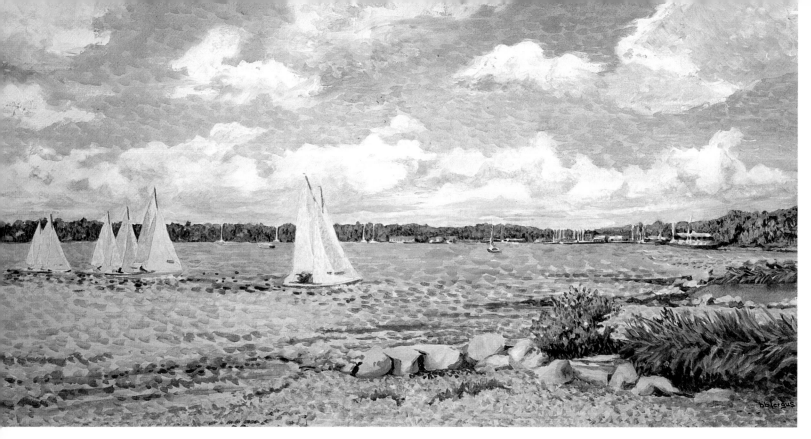

Bonnie Fergus
Harbor Sail
18" x 24" (46 cm x 61 cm)
Prestretched canvas

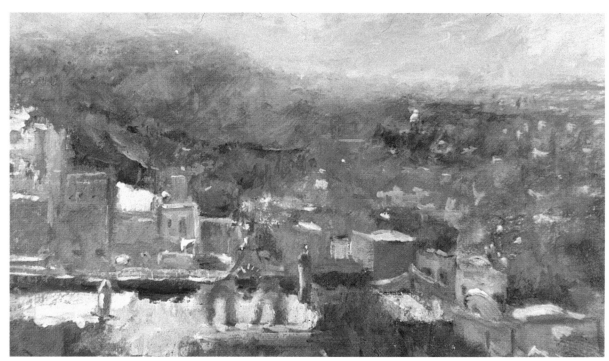

Linda Kessler
San Miguel de Allende, México
12" x 28" (30 cm x 71 cm)
Canvas

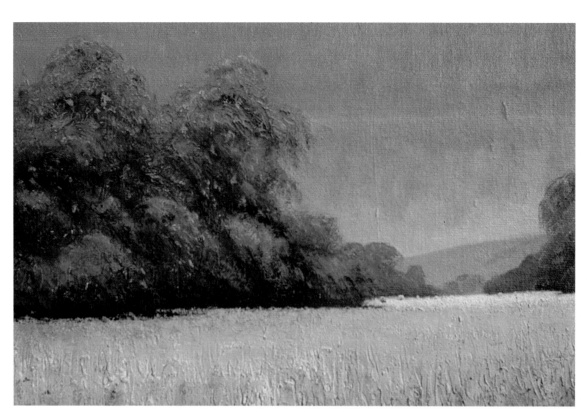

Bart O'Farrell
Summer Heat
10" x 14" (25 cm x 36 cm)
Canvas

Bart O'Farrell
July Pasture
12" x 16" (30 cm x 41 cm)
Board

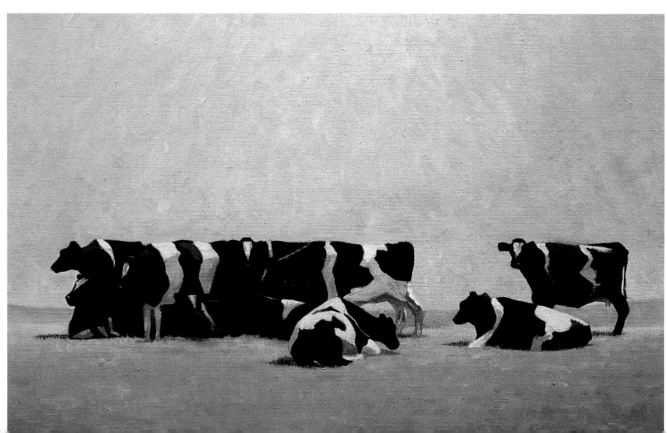

Bart O'Farrell
Dawn Picking
10" x 14" (25 cm x 36 cm)
Canvas

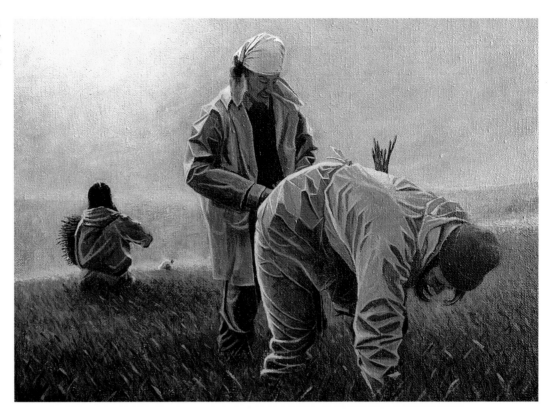

Bart O'Farrell
In the Daffodil Fields
36" x 48" (91 cm x 122 cm)
Canvas

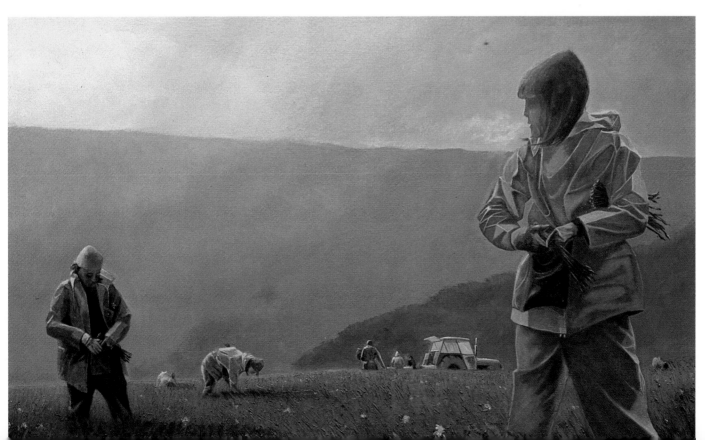

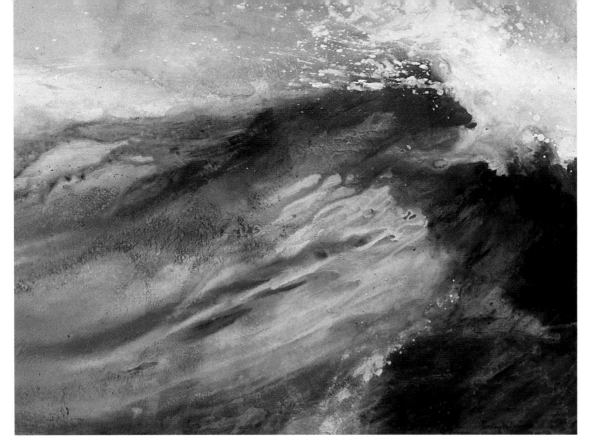

Dorothy Watkeys Barberis
Wind and Wave
30" x 42" (76 cm x 107 cm)
Arches watercolor board

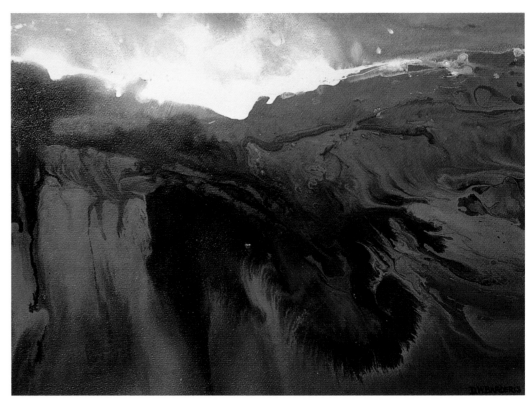

Dorothy Watkeys Barberis
Wave
21" x 29" (53 cm x 74 cm)
Arches watercolor board

Dorothy Watkeys Barberis
Night Surf
21" x 29" (53 cm x 74 cm)
Arches watercolor board

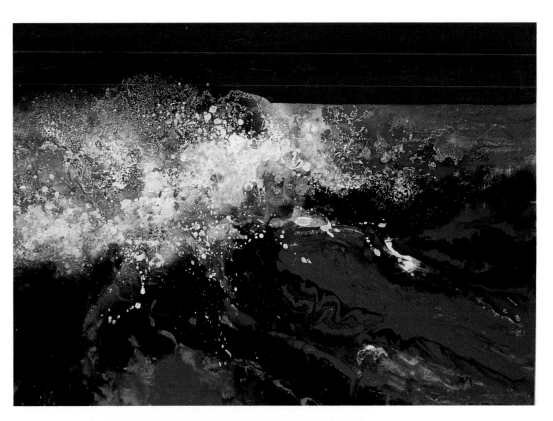

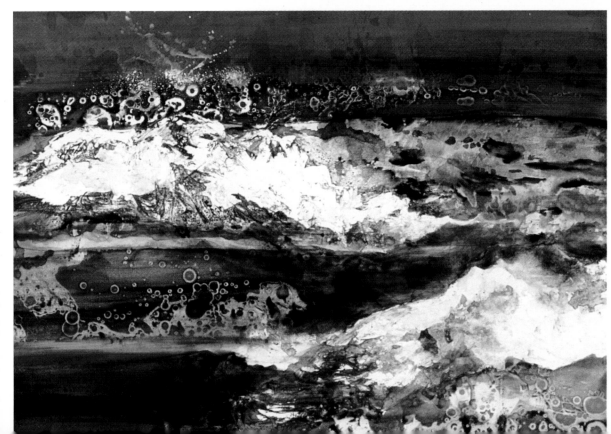

Betsy Gay
The Sea
23" x 29" (58 cm x 74 cm)
Acrylic with alcohol
Strathmore 500

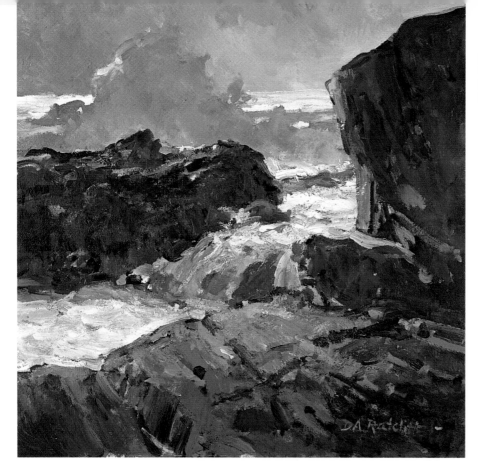

Dale Ratcliff
Crescendo
36" x 36" (91 cm x 91 cm)
Masonite gesso-coated .25″ board

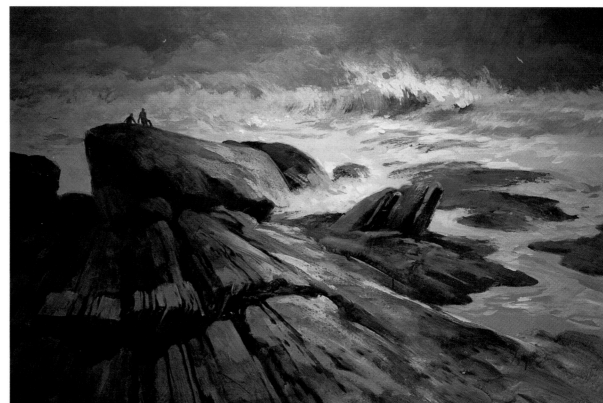

Don Getz
Dusk at Pemaquid
30" x 40" (76 cm x 102 cm)
Crescent No. 1
illustration board

Susan Lucas Updyke
Spirit of the Sierra
40" x 60" (102 cm x 152 cm)
Canvas

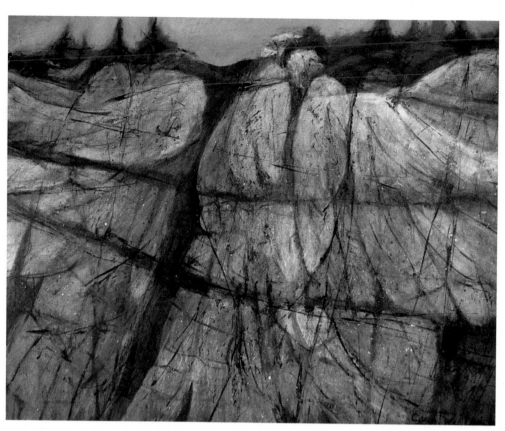

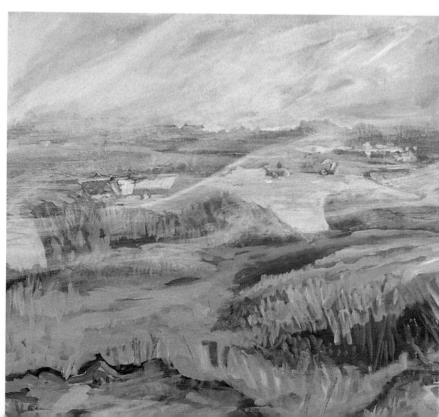

Judith Surowiec
When the Fog Rolls In
22" x 23" (56 cm x 58 cm)
Linen canvas

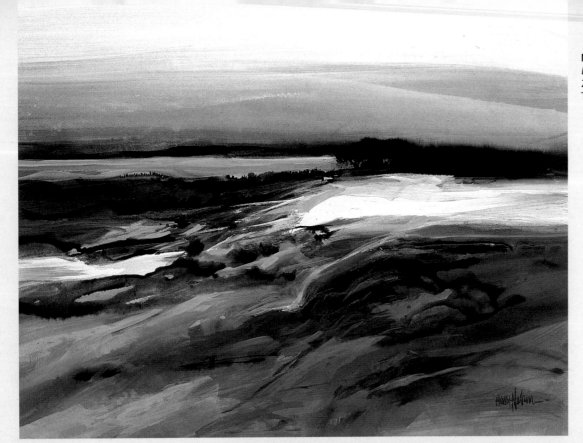

Marsh Nelson
Eventide
21" x 27" (53 cm x 68 cm)
Two-ply museum board

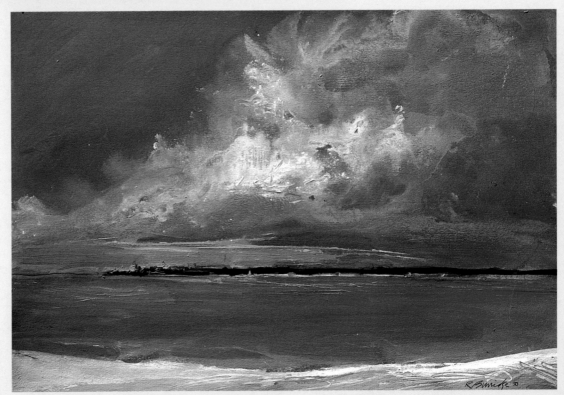

Robert Burridge
Seaview
30" x 40" (76 cm x 102 cm)
Lana Aquarelle 300 lb. cold press paper

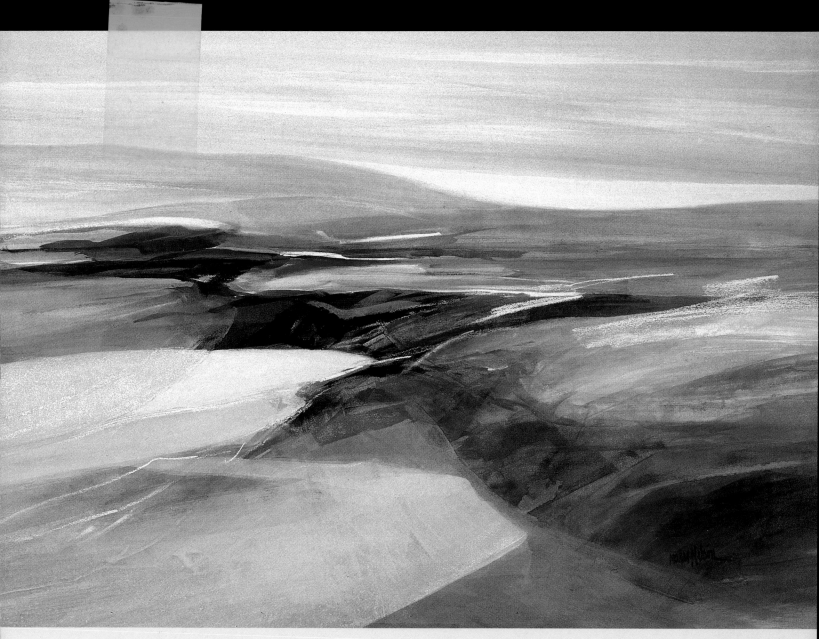

Marsh Nelson
Earth Shore
21" x 31" (53 cm x 79 cm)
Two-ply museum board

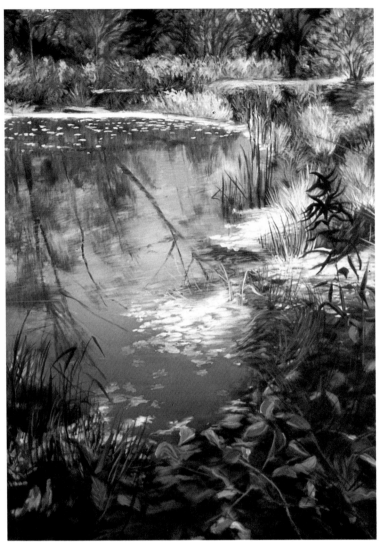
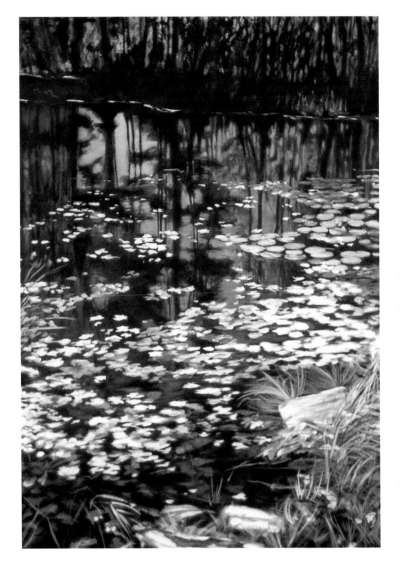

Judith Futral Evans
Pond Sonata Triptych
50" x 36" each (127 cm x 91 cm each)
Canvas

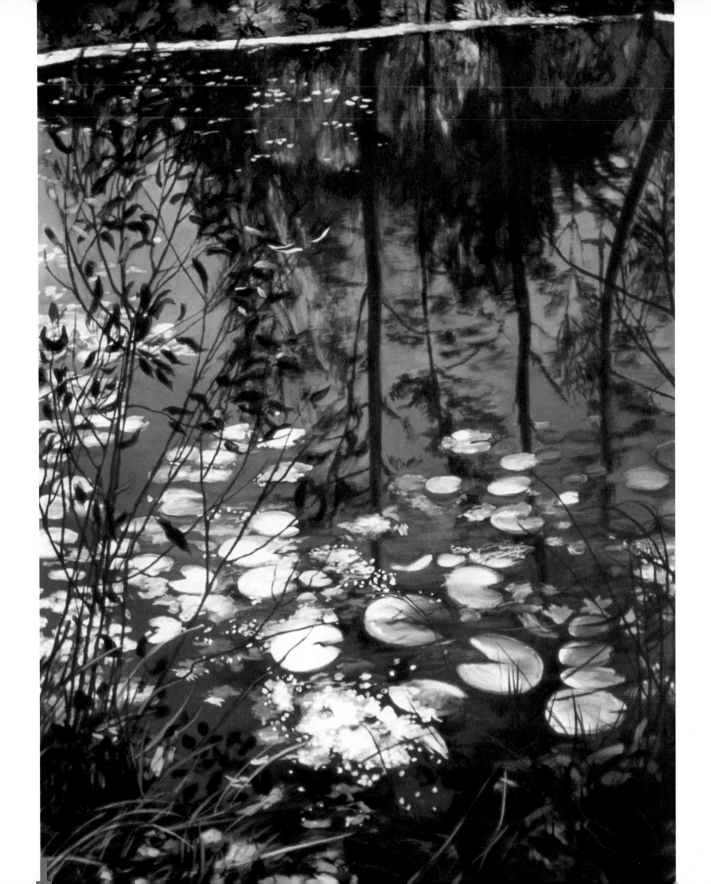

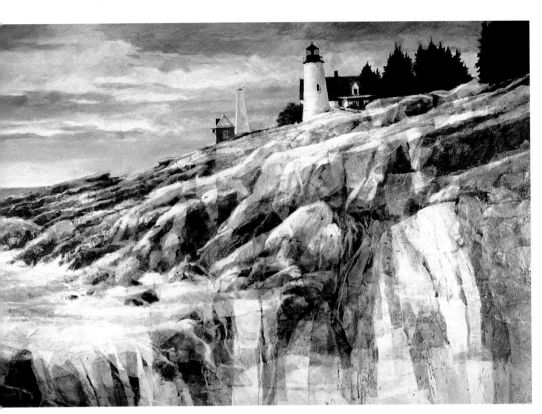

Gerald F. Brommer
Pemaquid
36" x 48" (91 cm x 122 cm)
Acrylic with washi (rice paper)
Canvas

Gerald F. Brommer
Greek Shadows
36" x 48" (91 cm x 122 cm)
Acrylic with washi (rice paper)
Canvas

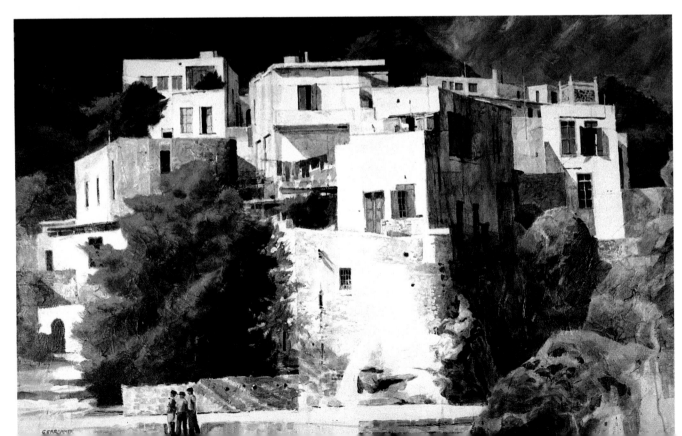

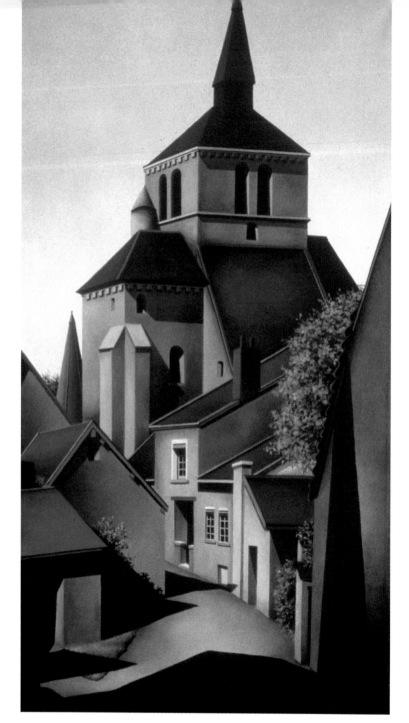

Carolyn Parker Lamunière
Street, Bèze
40" x 34" (102 cm x 86 cm)
Canvas on stretchers

Carolyn Parker Lamunière
Winter, Nyon
40" x 34" (102 cm x 86 cm)
Canvas on stretchers

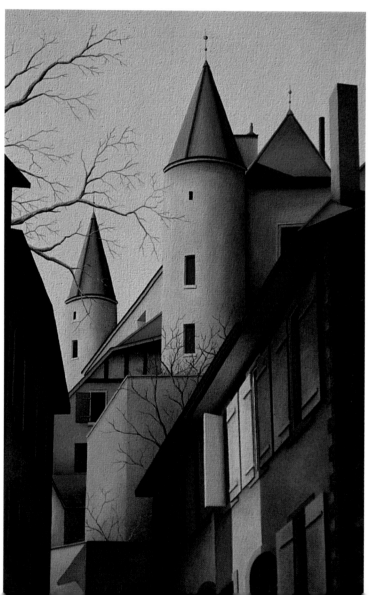

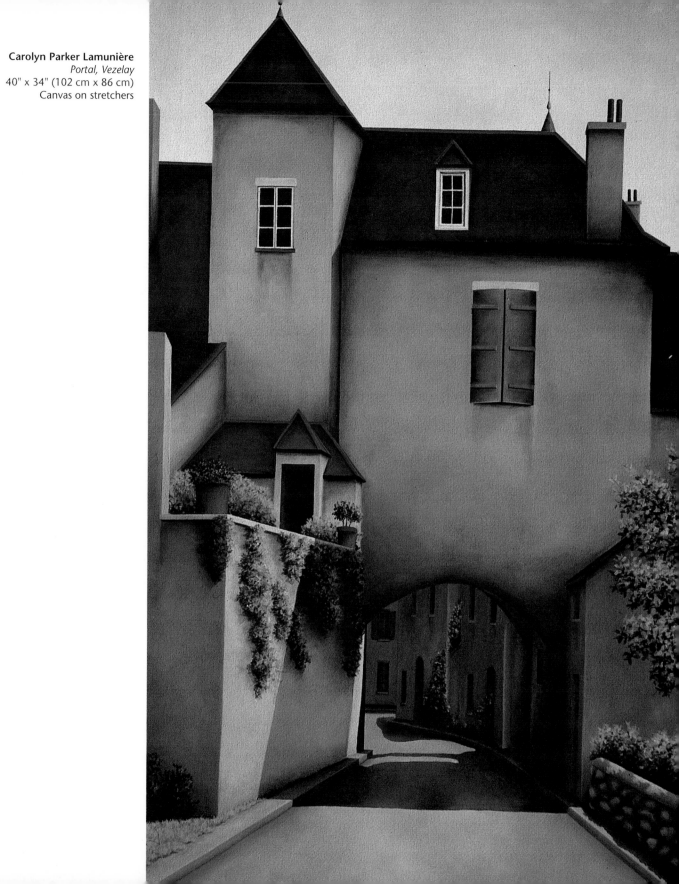

Carolyn Parker Lamunière
Portal, Vezelay
40" x 34" (102 cm x 86 cm)
Canvas on stretchers

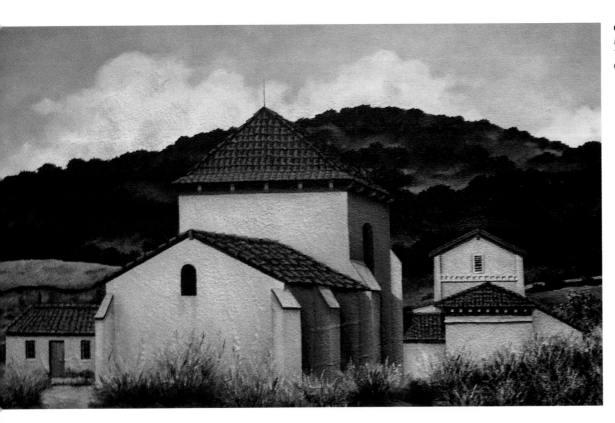

Carolyn Parker Lamunière
Monastery, Escalada
18" x 28" (46 cm x 71 cm)
Canvas on stretchers

Carolyn Parker Lamunière
Purple Light, Chaoven
36" x 40" (91 cm x 102 cm)
Canvas on stretchers

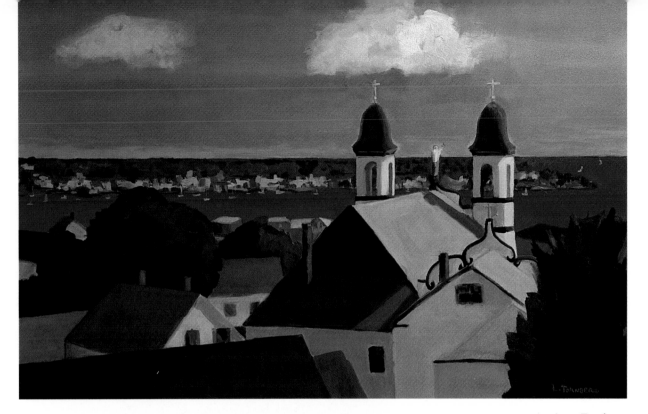

Lynn Tornberg
Our Lady
26" x 38" (66 cm x 97 cm)
Canvas

Lynn Tornberg
Hampden Hill
31" x 25" (79 cm x 64 cm)
Canvas

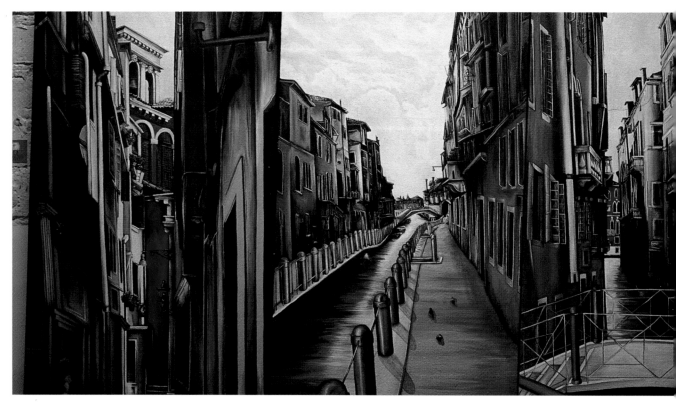

Gaye Elise Beda
Venetian Triptych
25" x 42"
(64 cm x 107 cm)
Portrait linen

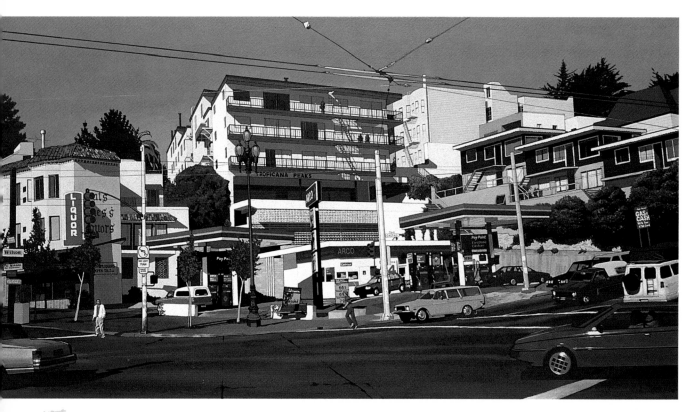

Glenn Moreton
Castro Gas
26" x 48"
(66 cm x 122 cm)
Canvas

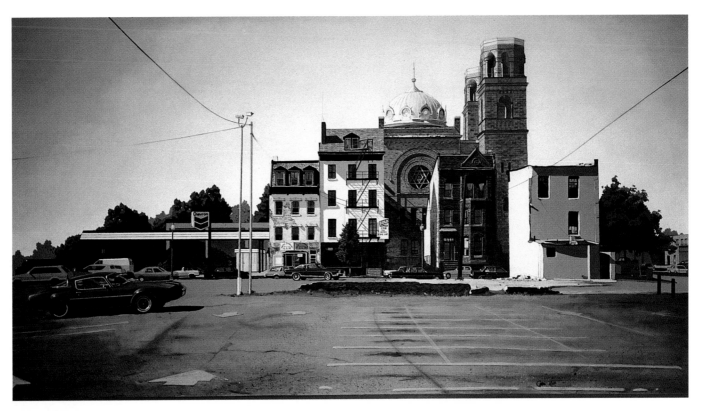

Glenn Moreton
Chinatown Shul
26" x 48"
(66 cm x 122 cm)
Canvas

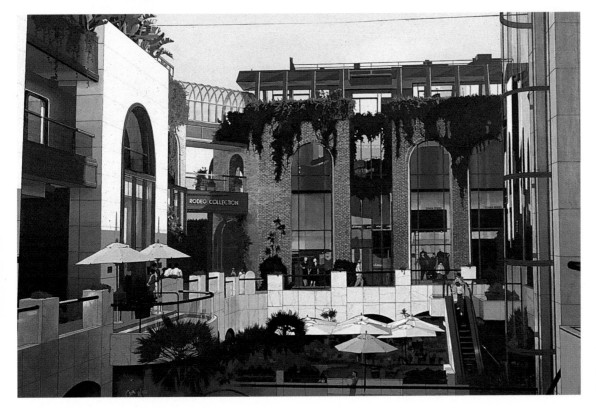

Glenn Moreton
Rodeo
24" x 36" (61 cm x 91 cm)
Canvas

45

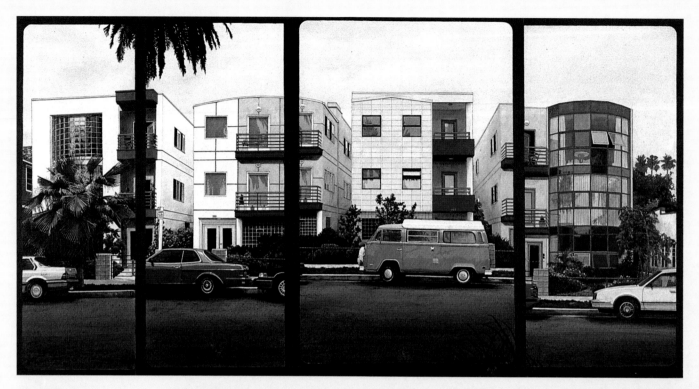

Glenn Moreton
Venice: Vans
24" x 46" (61 cm x 117 cm)
Canvas

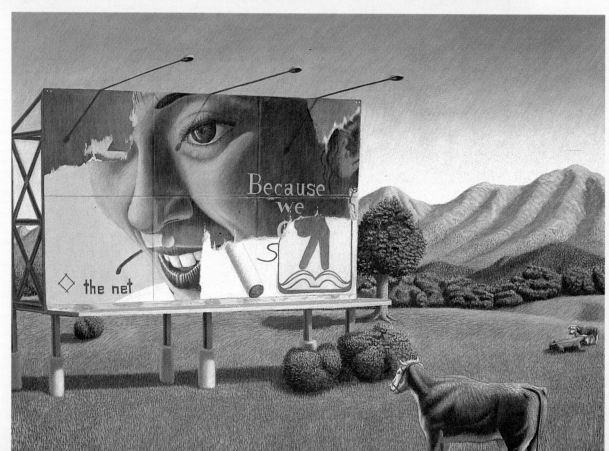

Mark Elder
F.Y.I.
29" x 39" (74 cm x 99 cm)
Canvas

Ellen Westendorf Lane
Stepping Out
46" x 38"
(117 cm x 97 cm)
Canvas

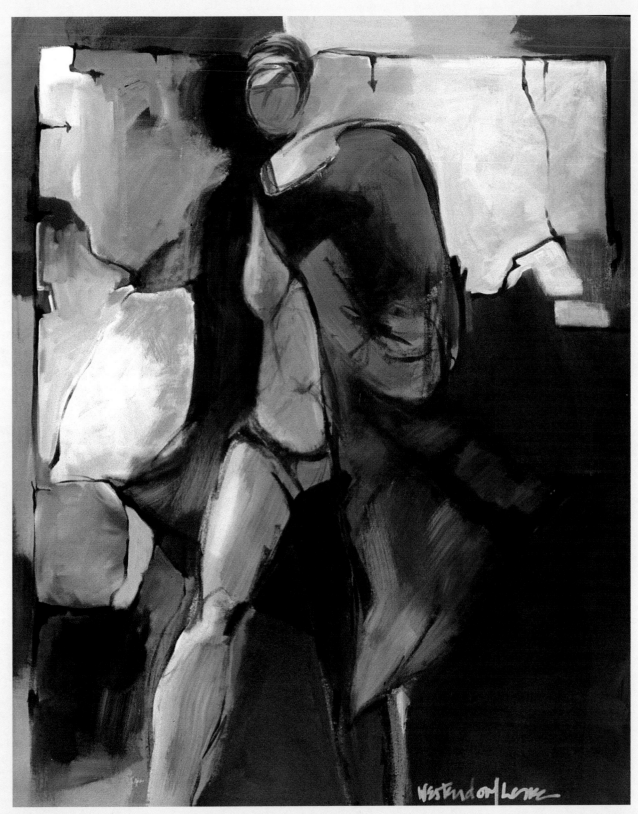

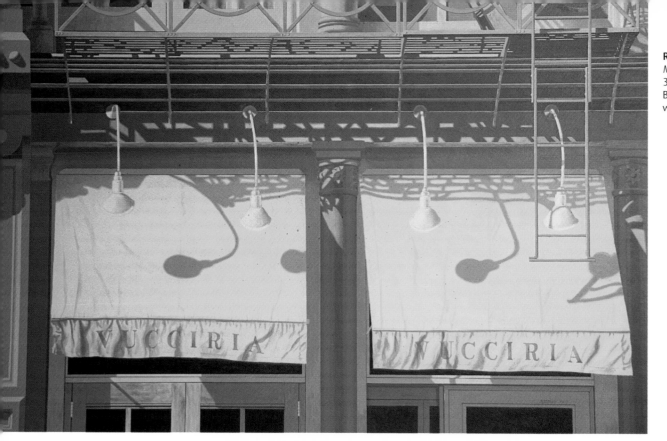

Richard Brzozowski
Meat Market
30" x 40" (76 cm x 102 cm)
Bainbridge #181 cold press
watercolor board

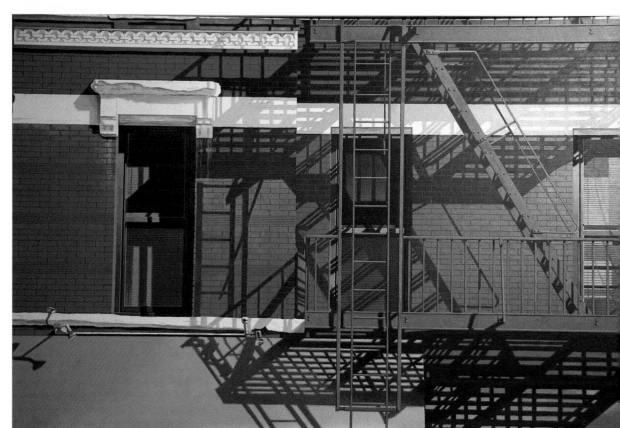

Richard Brzozowski
City Lights
29" x 40" (74 cm x 102 cm)
Bainbridge #181 cold press
watercolor board

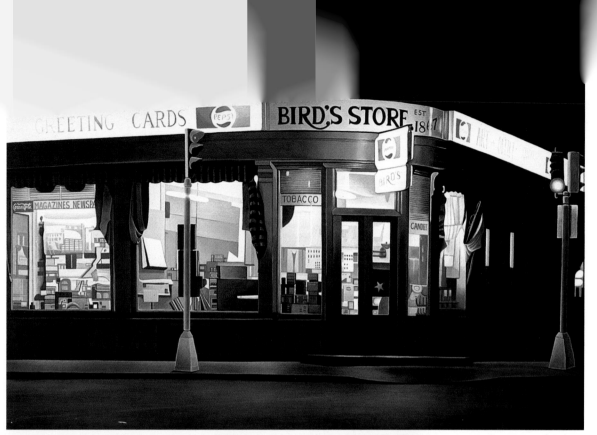

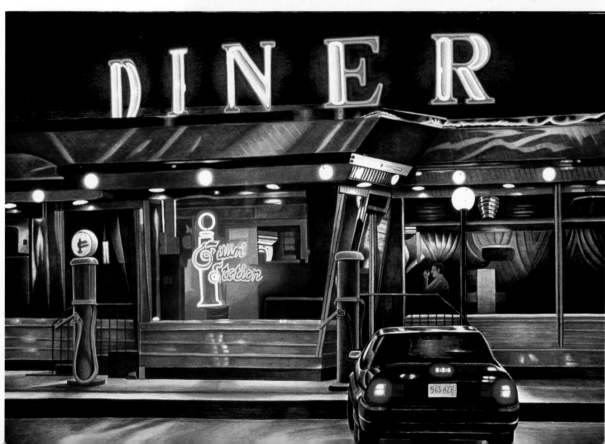

Bill Rohan
Fillin' Station
15" x 20" (38 cm x 51 cm)
Masonite gesso-coated board

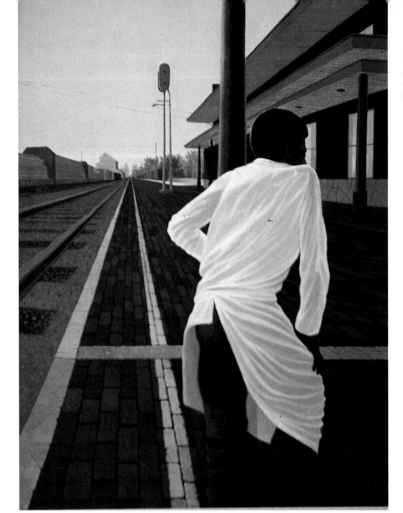

Rolland Golden
All Tracks Lead to New Orleans
40" x 30" (102 cm x 76 cm)
Canvas

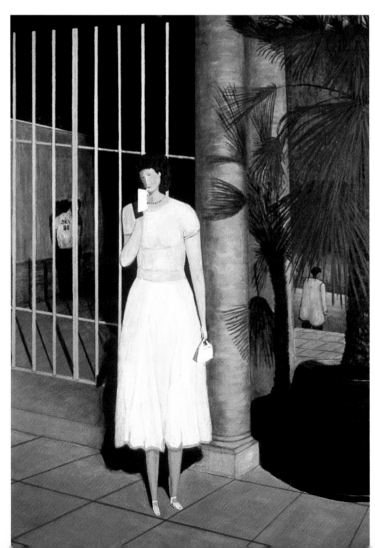

Petr Liska
Moment at Marienbad
36" x 24" (91 cm x 61 cm)
Canvas

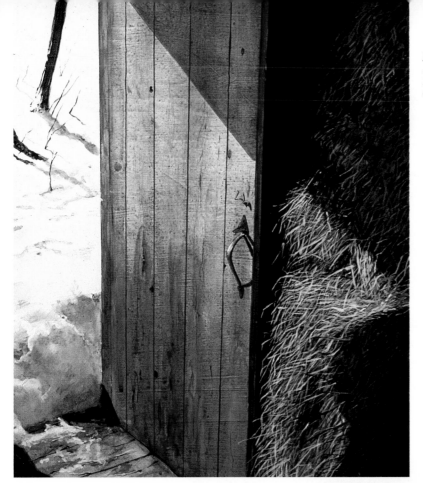

John de Soto
Morning Light
28" x 18" (71 cm x 46 cm)
Gesso-coated panel

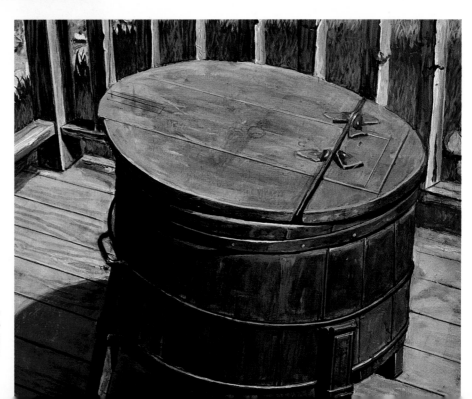

John de Soto
Washtub
16" x 20" (41 cm x 51 cm)
Gesso-coated panel

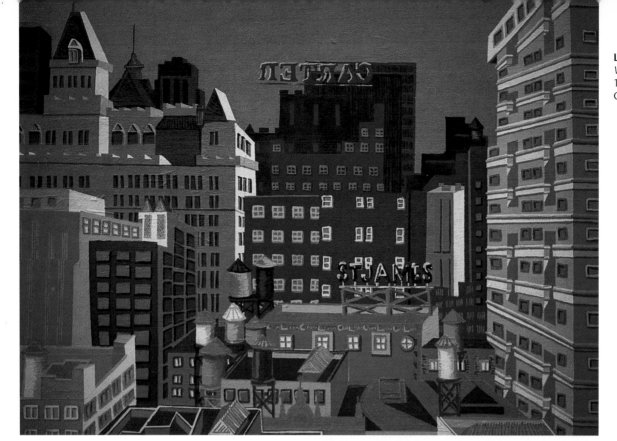

Lynda Andrews-Barry
View from Room 1134 or 35
14" x 18" (36 cm x 46 cm)
Canvas

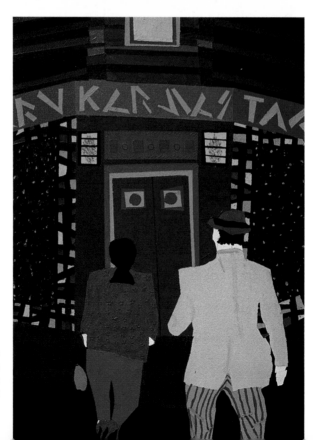

Lynda Andrews-Barry
Karavas Tavern
30" x 24" (76 cm x 61 cm)
Canvas

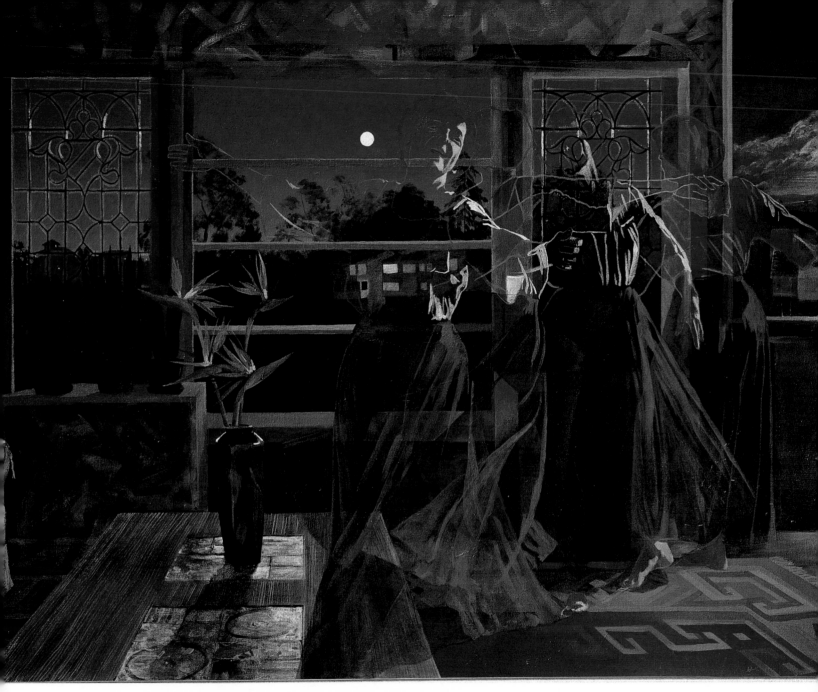

Lawrence Wallin
Moonlight Nocturn
36" x 48" (91 cm x 122 cm)
Canvas

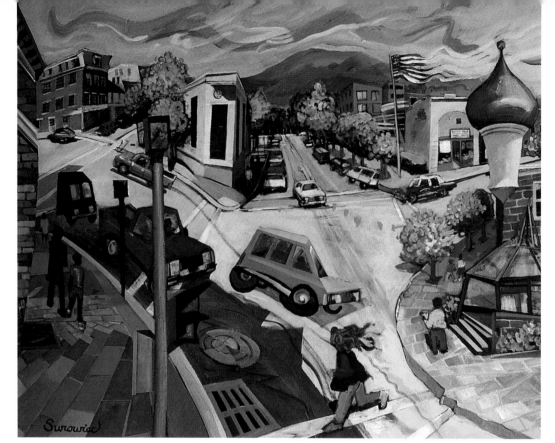

Judith Surowiec
Peekskill Crossing
20" x 24" (51 cm x 61 cm)
Linen canvas

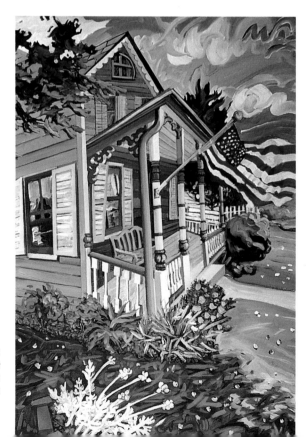

Judith Surowiec
Summer House
32" x 21" (81 cm x 53 cm)
Linen canvas

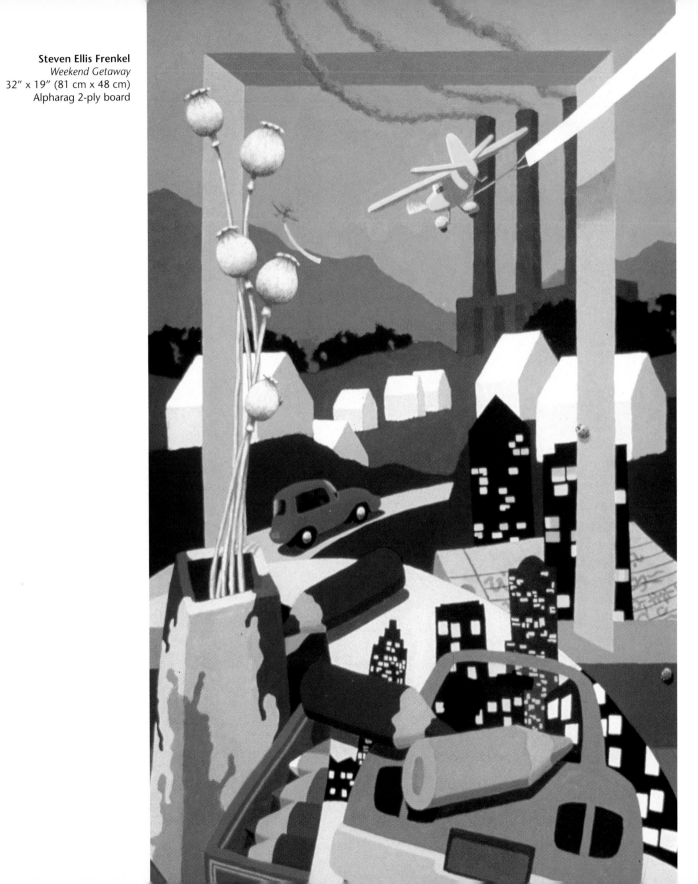

Steven Ellis Frenkel
Weekend Getaway
32" x 19" (81 cm x 48 cm)
Alpharag 2-ply board

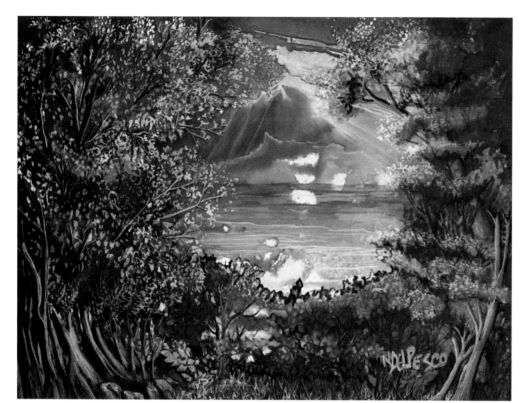

Nancy Del Pesco/Thornton
Early Morn
25" x 30" (64 cm x 76 cm)
Acrylic with watercolor underpainting
140 lb. Watercolor paper

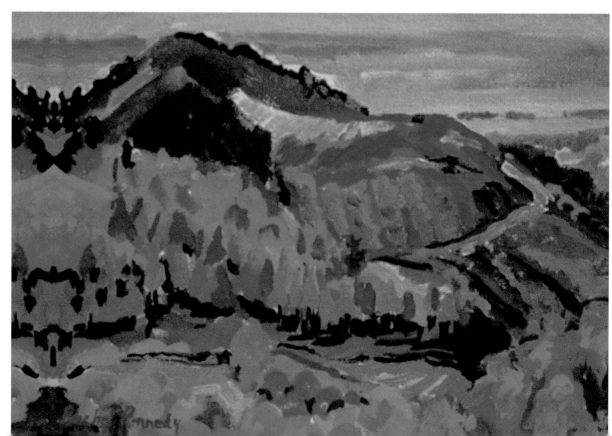

Rachael Kennedy
Les Beaux
15" x 28" (38 cm x 71 cm)
Canvas

56

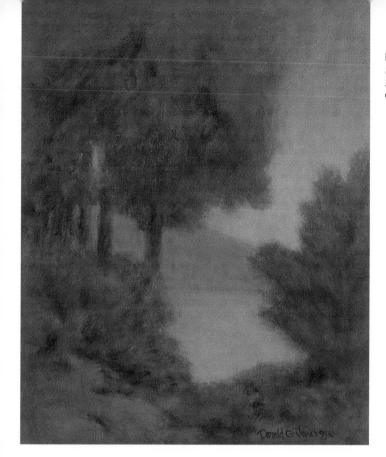

Donald Jones
Lake Overholser Cove
22" x 18" (56 cm x 46 cm)
Canvas

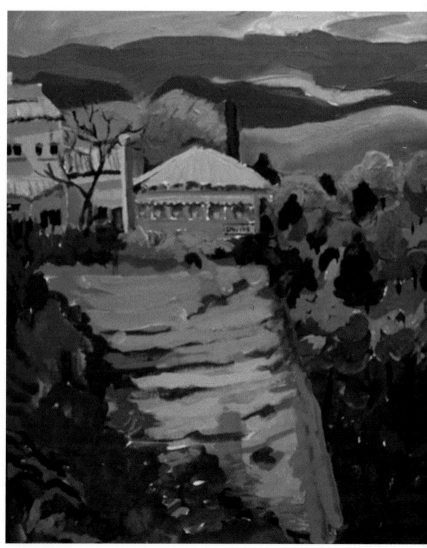

Rachael Kennedy
In the Provence Valley
20" x 15" (51 cm x 38 cm)
Canvas

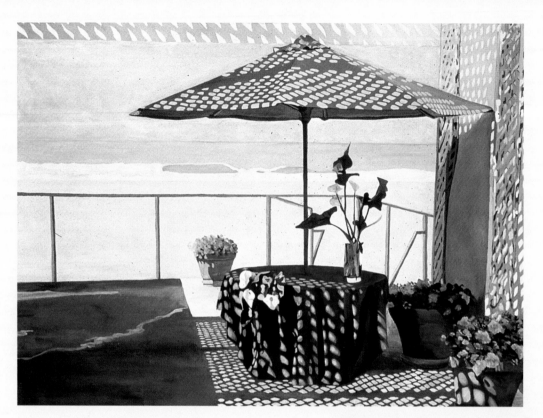

Mark Lee Goldberg
Seymour's Patio
36" x 48" (91 cm x 122 cm)
Canvas

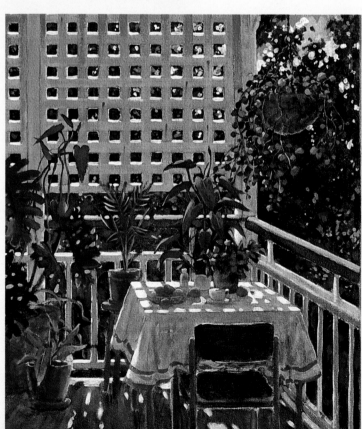

Christine F. Atkins
Apples and Oranges
31" x 22" (79 cm x 56 cm)
Canvas

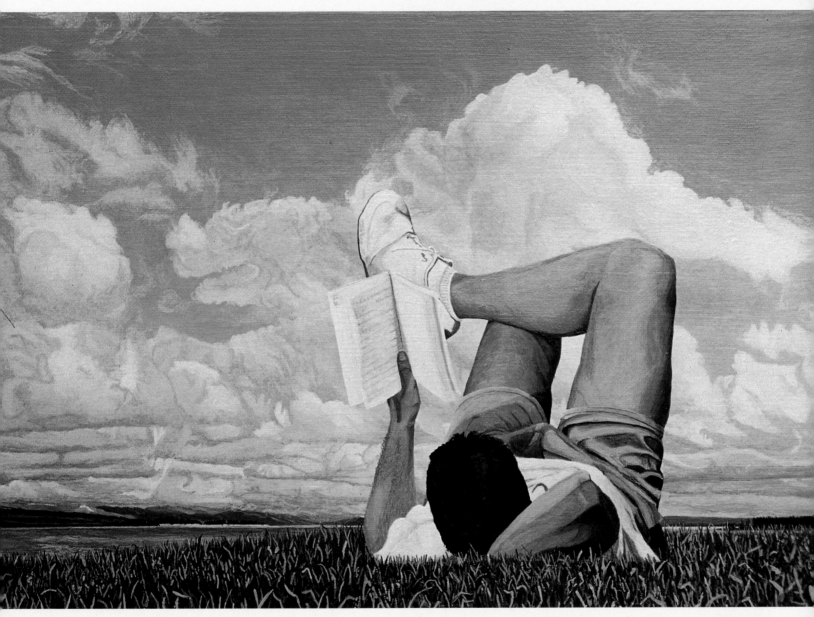

Tim Flanagan
Beyond Boundaries
12" x 18" (30 cm x 45 cm)
Canvas

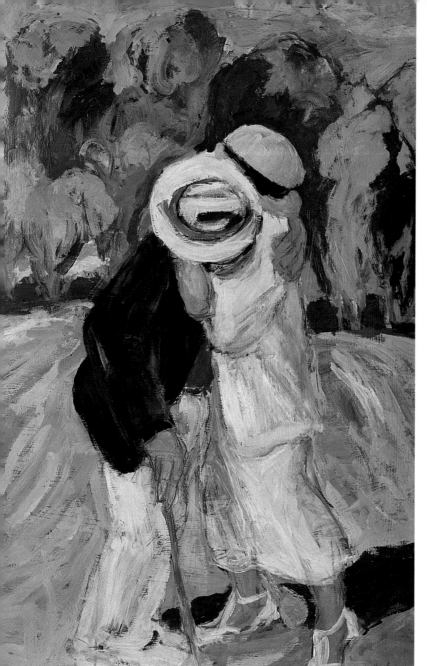

A. M. Lawtey
Sunday Afternoon Croquet
38" x 24" (94 cm x 61 cm)
Acrylic with watercolor crayon
Cover weight oak tag

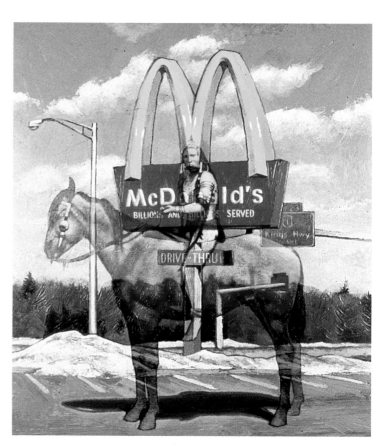

Gordon Carlisle
Spirit of America
55" x 48" (140 cm x 122 cm)
Constructed plywood surface

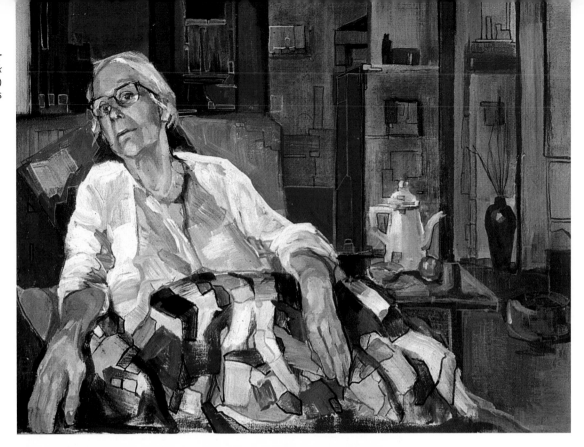

Edith Hodge Pletzner
Patchwork
18" x 24" (46 cm x 61 cm)
Canvas

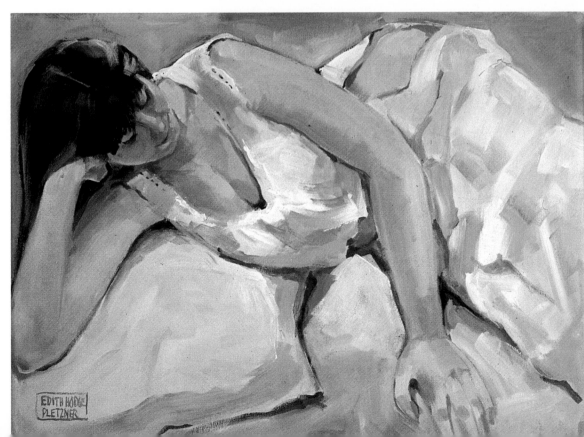

Edith Hodge Pletzner
Victorian Slip
18" x 24" (46 cm x 61 cm)
Canvas

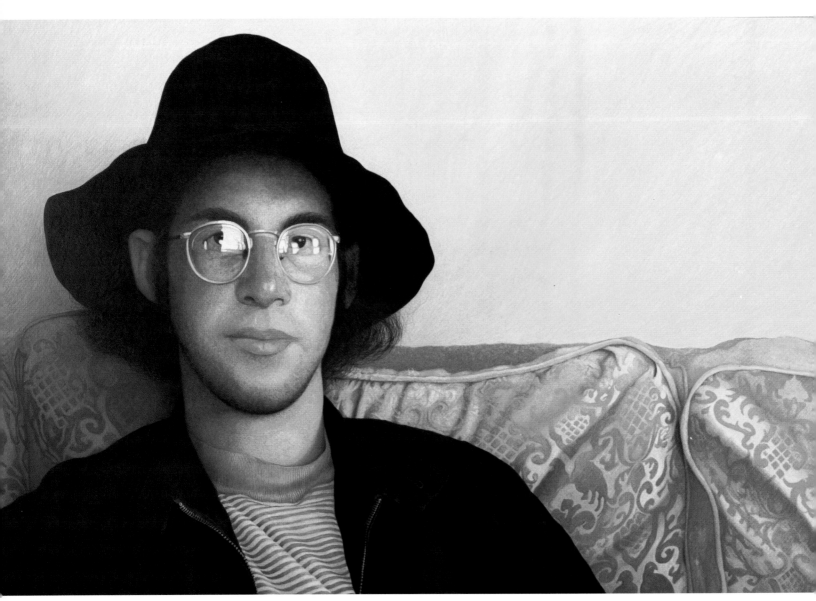

Douglas Wiltrant
The Visitor
22" x 34" (56 cm x 86 cm)
Masonite gesso-coated panel

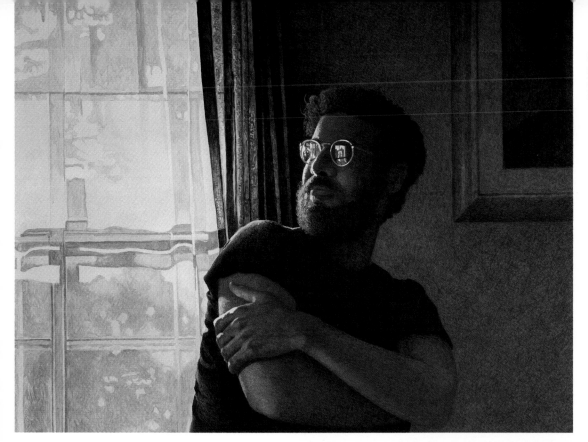

Douglas Wiltrant
Looking Toward Evening
21" x 27" (53 cm x 69 cm)
Masonite gesso-coated panel

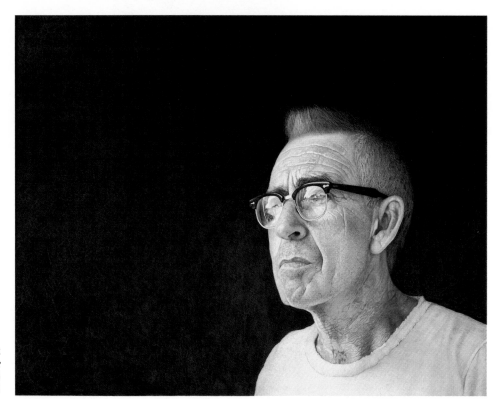

Douglas Wiltrant
Vintage
23" x 29" (58 cm x 74 cm)
Masonite gesso-coated panel

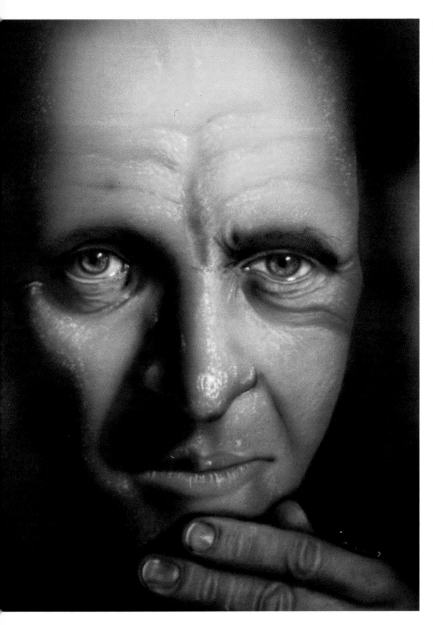

Johanne M. Gimbrone
Portrait of Anthony Hopkins (actor)
17" x 13" (43 cm x 33 cm)
Frisk CS-10 illustration board

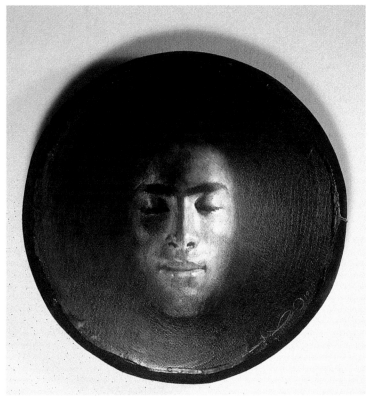

Shozo Nagano
Ancient Memory
11" x 11" (28 cm x 28 cm)
Cotton Duck canvas

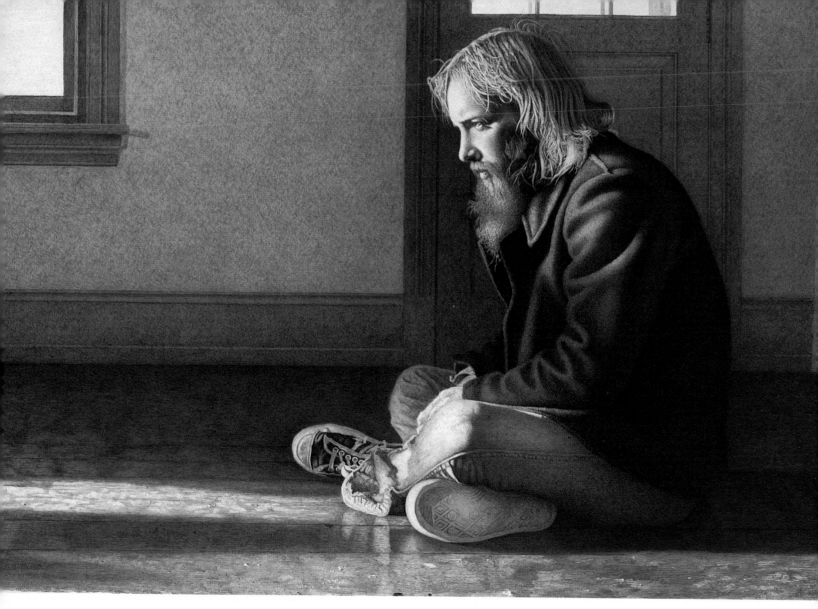

Douglas Wiltrant
Mourning Dove
28" x 42" (71 cm x 107 cm)
Masonite gesso-coated panel

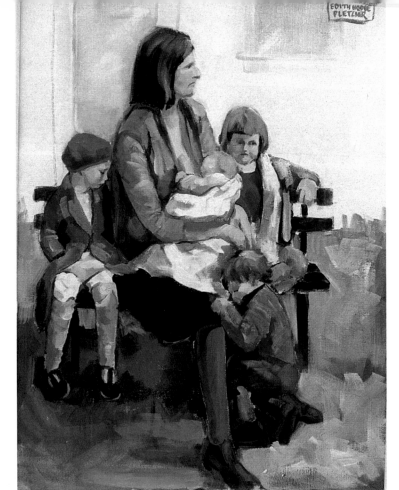

Edith Hodge Pletzner
Migrant Family
24" x 18" (61 cm x 46 cm)
Canvas

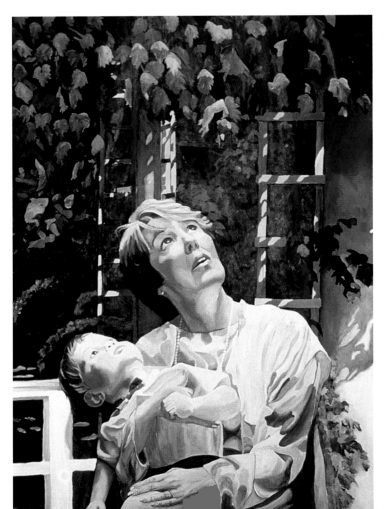

Mark Lee Goldberg
Light from Above
48" x 36" (122 cm x 91 cm)
Canvas

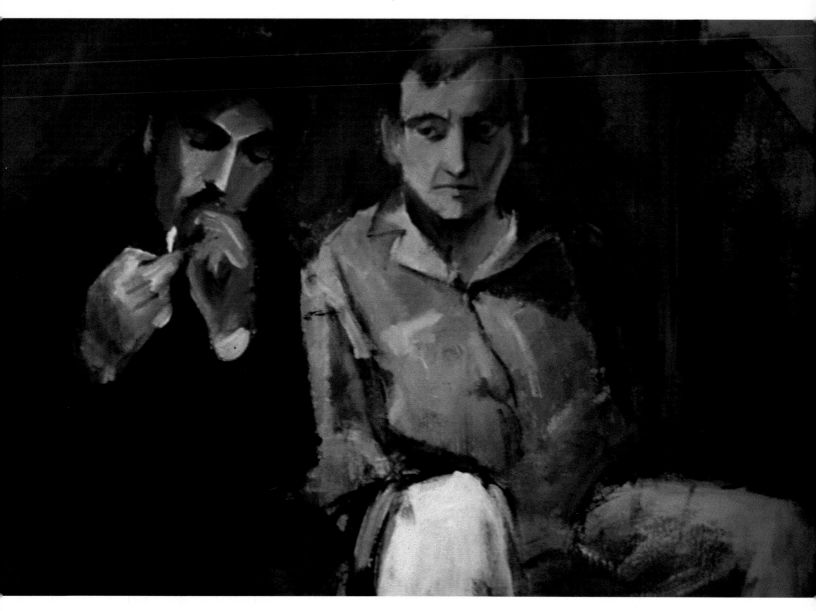

D. Wels
The Smoker
44" x 60" (112 cm x 152 cm)
Canvas

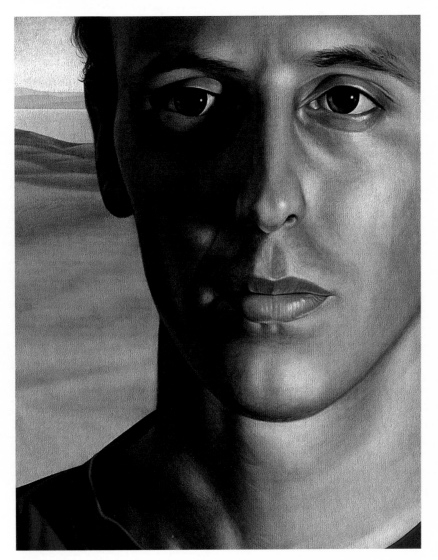

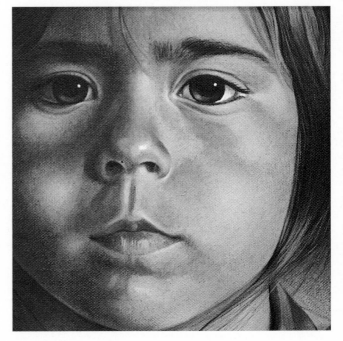

Patrick Fiore
Yaron Inbar
20" x 16" (51 cm x 41 cm)
Canvas mounted on board

Patrick Fiore
Ana
6" x 6" (15 cm x 15 cm)
Canvas mounted on board

Patrick Fiore
Untitled
10" x 7" (25 cm x 18 cm)
Canvas mounted on board

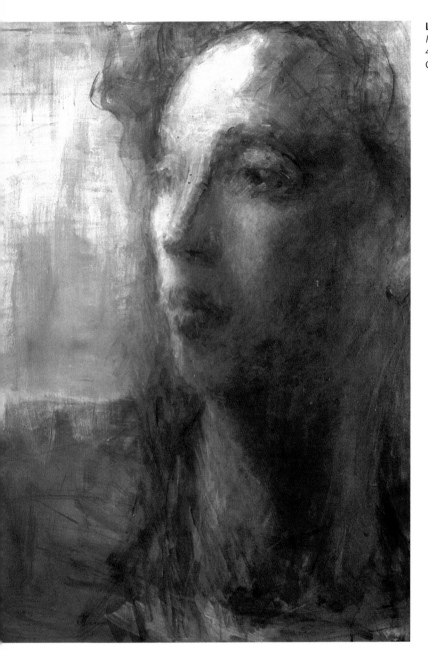

Linda Kessler
Purple Lady
40" x 30" (102 cm x 75 cm)
Canvas

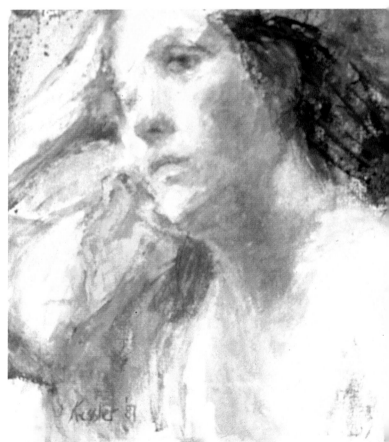

Linda Kessler
Portrait of Ms. Prudhomme
12" x 12" (30 cm x 30 cm)
Canvas

Linda Kessler
Black Man
24" x 24" (60 cm x 60 cm)
Canvas

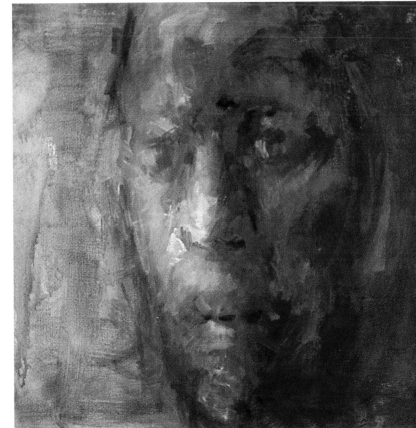

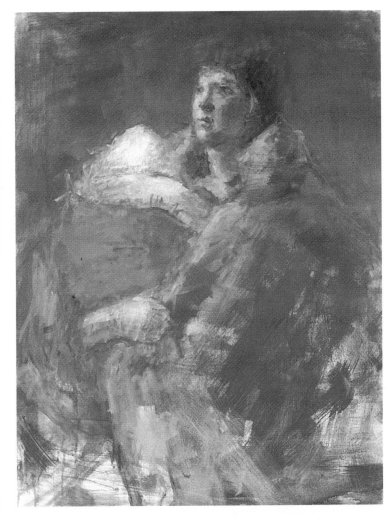

Linda Kessler
Mother and Child
40" x 30" (102 cm x 76 cm)
Canvas

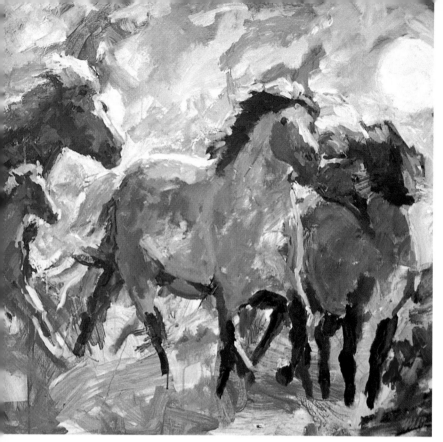

William St. George
Icelandic Ponies
36" x 36" (91 cm x 91 cm)
Canvas

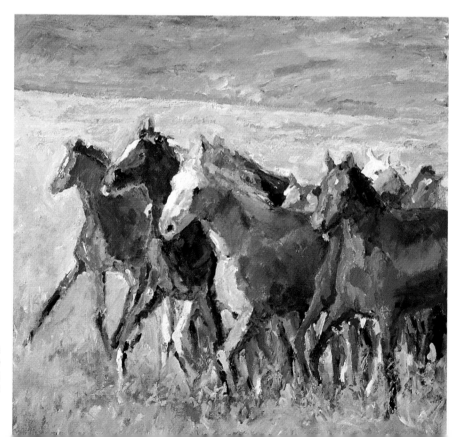

William St. George
Freedom
36" x 36" (91 cm x 91 cm)
Canvas

72

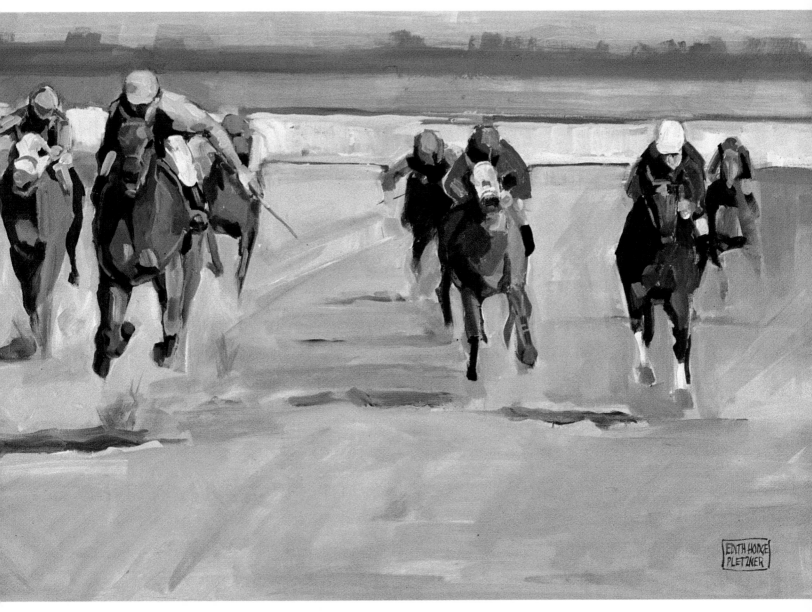

Edith Hodge Pletzner
Home Stretch
24" x 36" (61 cm x 91 cm)
Canvas

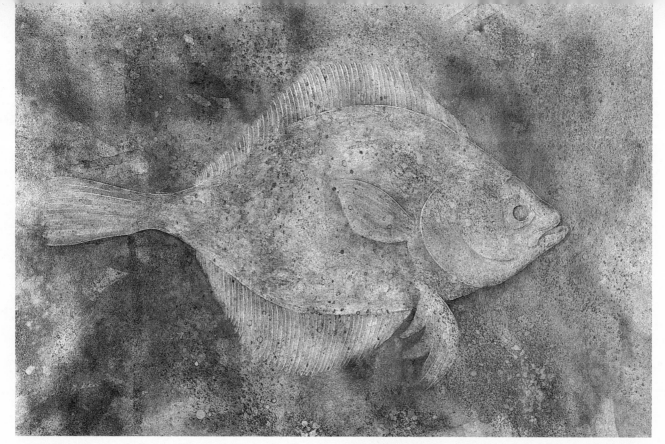

Sandra I. Fraser
Of the Sea
24" x 36" (61 cm x 92 cm)
Acrylic with gesso and dry metallic powder
140 lb. watercolor paper

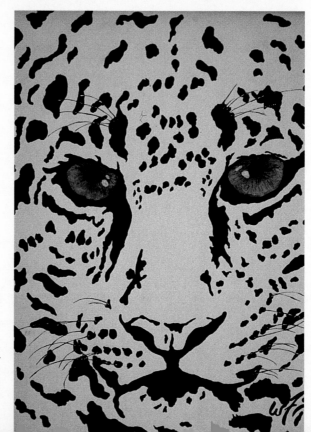

William Smith
Watcher
24" x 20" (60 cm x 50 cm)
Canvas

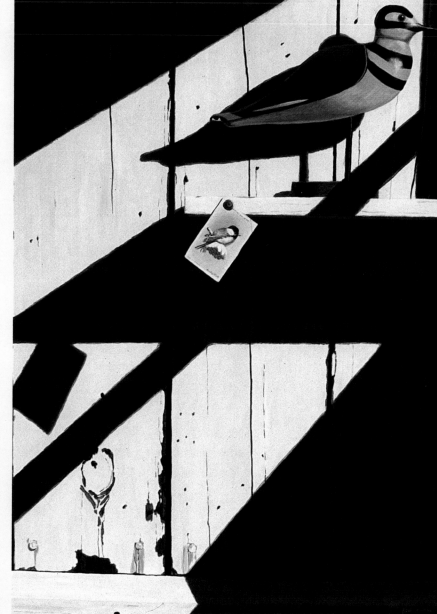

Don Henson
From Baking Soda to the Highway
29" x 22" (72 cm x 55 cm)
Masonite board

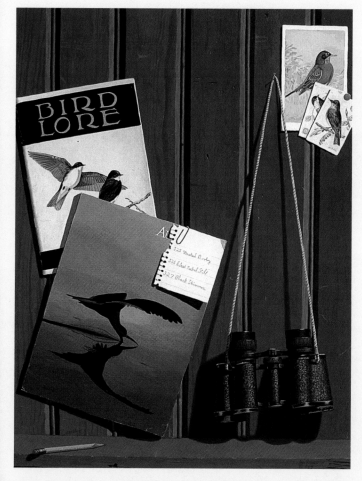

Don Henson
Life List
26" x 20" (65 cm x 50 cm)
Masonite board

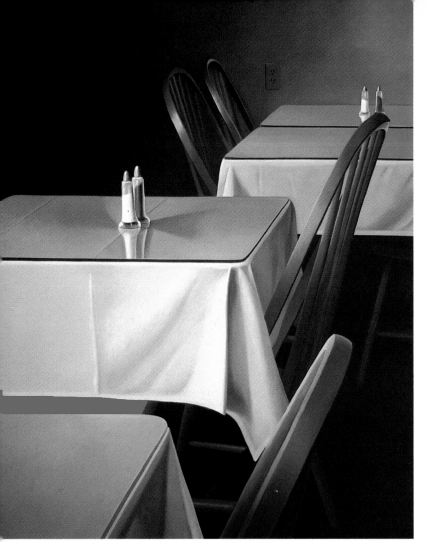

Laura Anderson
Boatyard Cafe #3
30" x 24" (76 cm x 61 cm)
Canvas

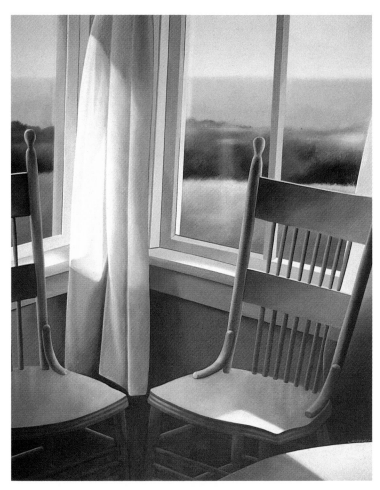

Laura Anderson
Her Corner #2
30" x 24" (76 cm x 61 cm)
Canvas

Laura Anderson
3 Green Rockers
30" x 40" (76 cm x 102 cm)
Ultrasmooth canvas

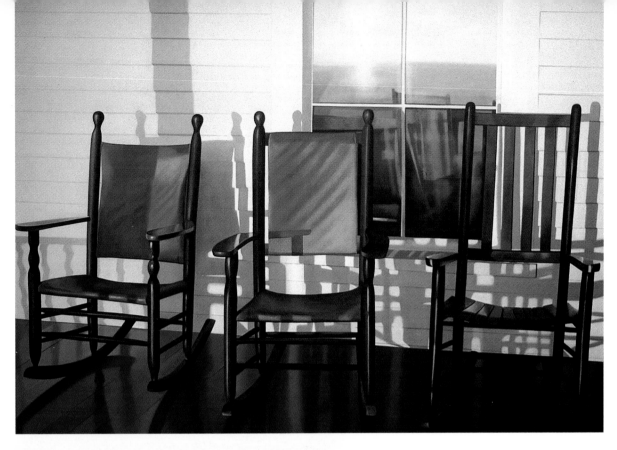

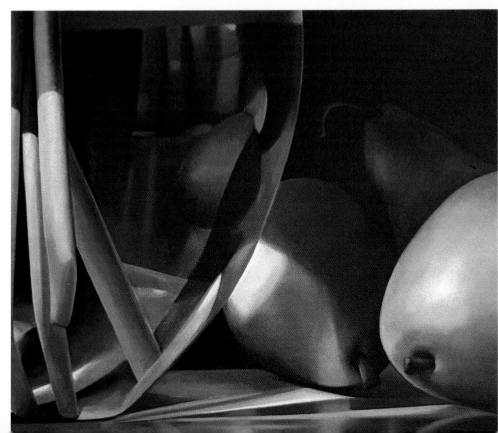

Laura Anderson
Pear Reflections
12" x 12" (30 cm x 30 cm)
Canvas

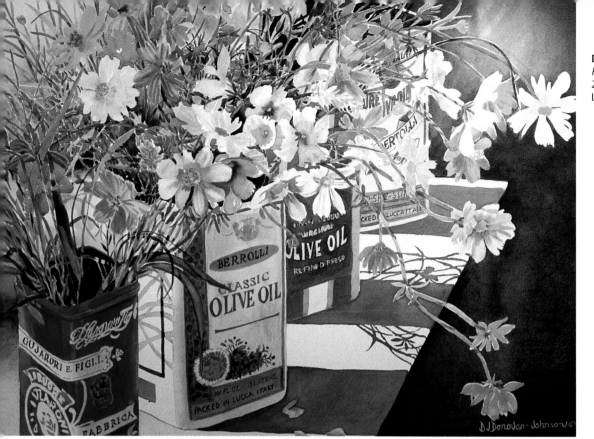

DJ Donovan-Johnson
Farmers Market Cosmos
22" x 30" (56 cm x 76 cm)
Lana Aquarelle 300 lb. cold press paper

Bonnie Fergus
Michigan Memories
32" x 30" (81 cm x 76 cm)
Arches 300 lb. cold press watercolor paper

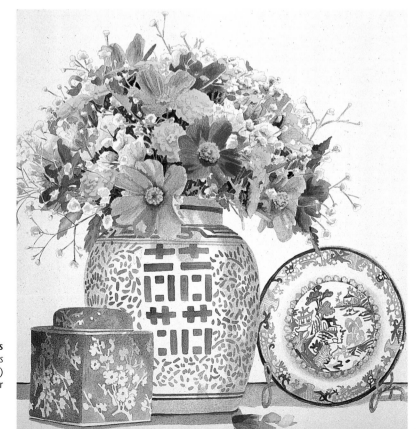

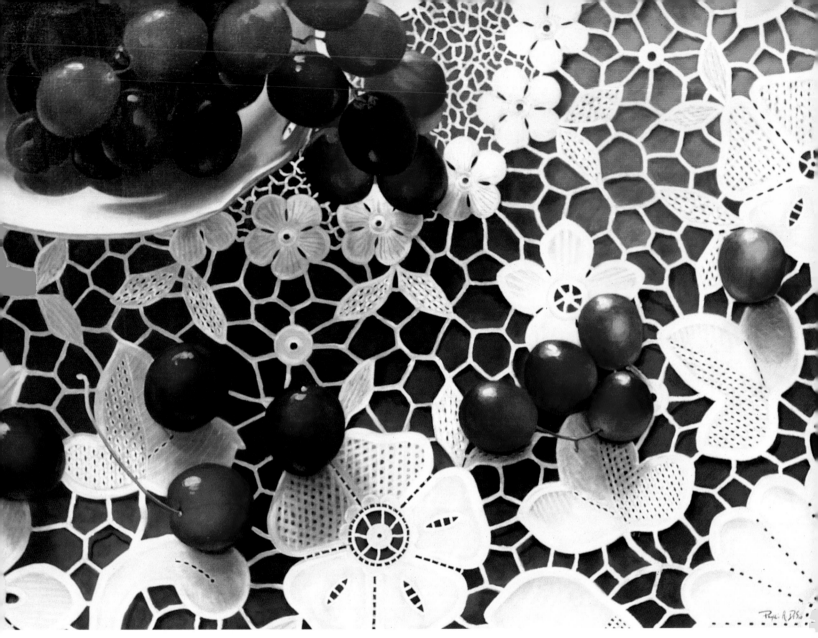

Phyllis A. De Sio
Grandmother's Lace with Grapes
32" x 45" (81 cm x 114 cm)
Cotton duck gesso-coated canvas

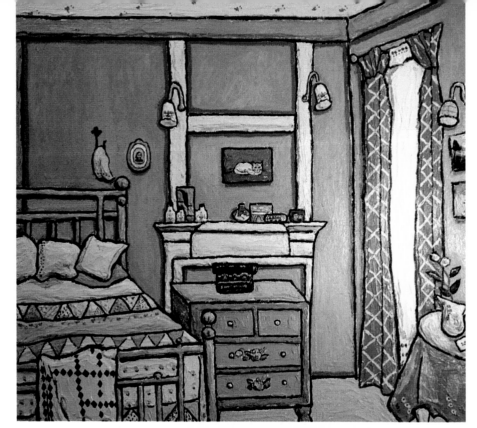

Leslie Lew Burns
Home Sweet Home
20" x 18" (51 cm x 46 cm)
100% Rag cast paper

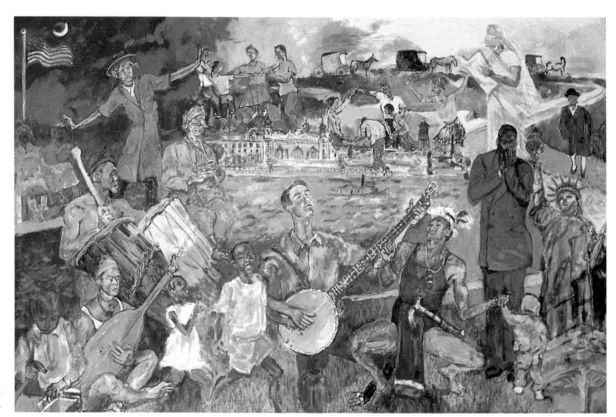

Sidney Findling
Immigrants U.S.A.
24" x 36" (61 cm x 91 cm)
Linen canvas

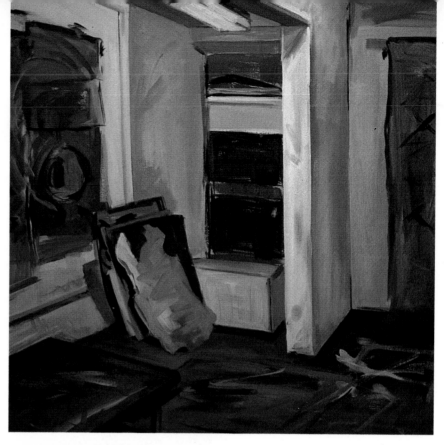

Elaine Caramagna
The Studio
36" x 36" (91 cm x 91 cm)
Bristol board

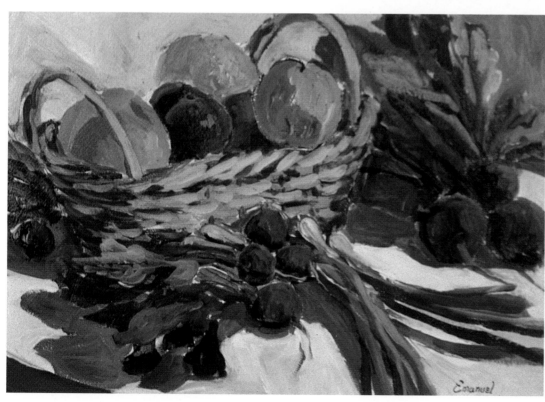

Reneé Emanuel
Still Life with Beets
20" x 24" (51 cm x 61 cm)
Lana Aquarelle 140 lb. cold press
gesso-coated paper

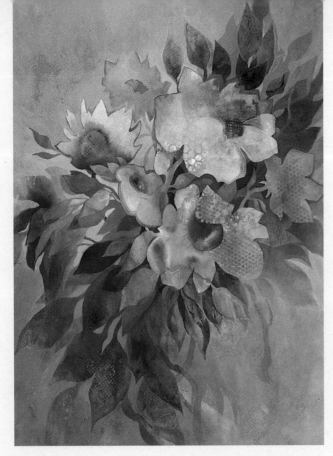

Carol Z. Brody
Blue Flowers
30" x 22" (76 cm x 56 cm)
Lana Aquarelle 140 lb. paper

Joseph J. Correale, Jr.
Wine Bottles
17" x 30" (43 cm x 76 cm)
Canvas

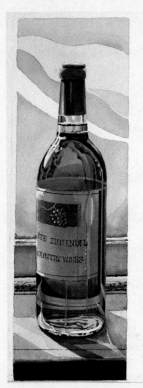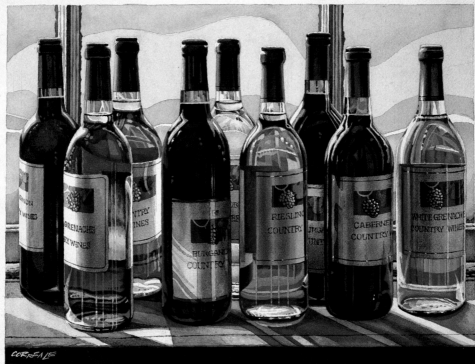

Betty Welch
The Arrangement
22.5" x 25.5" (57 cm x 65 cm)
Crescent #110 illustration board

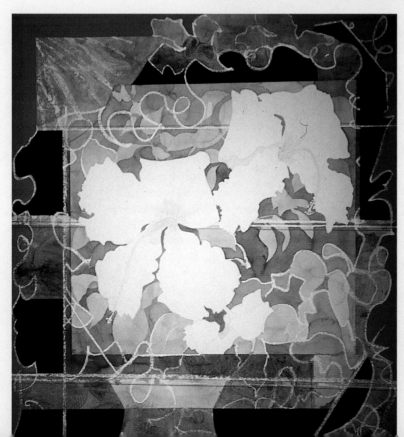

Betty Welch
Hibiscus Series
30" x 27" (76 cm x 69 cm)
Crescent #110 illustration board

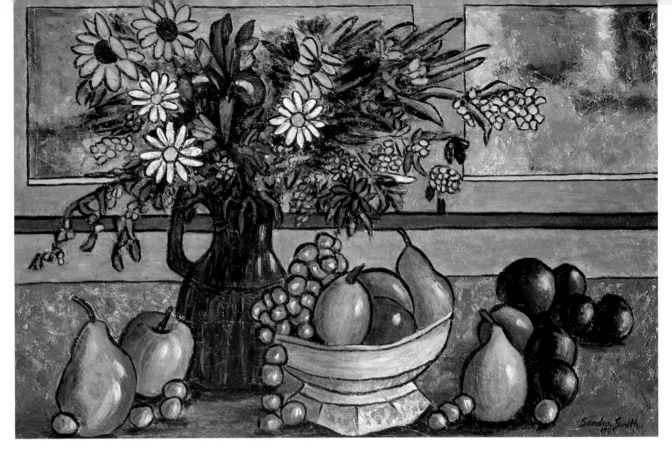

Sandra Lee Smith
Flowers & Fruit
24" x 36" (60 cm x 90 cm)
Canvas

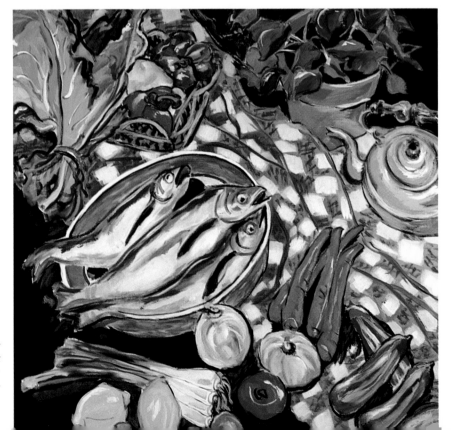

Lois Schachter
Ready To Cook
36" x 36" (91 cm x 91 cm)
Stretched cotton canvas

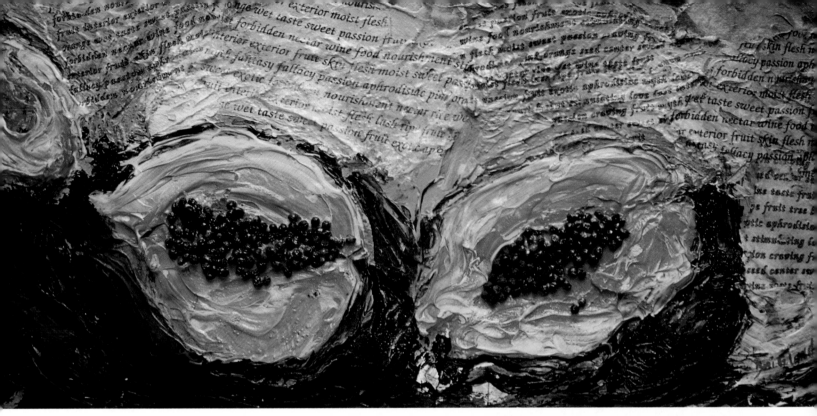

Dori Grace U. Lemeh
Passion Fruit
4" x 6.5" (10 cm x 17 cm)
Acrylic with seeds and sand
80 lb. Paper

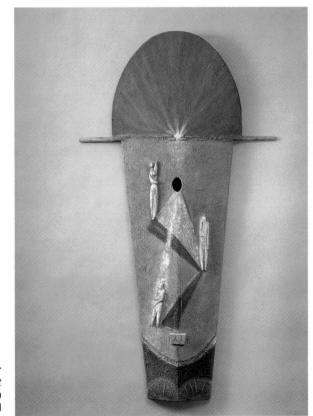

John Boomer
Dreams of Evening Light
63.5" x 36" (161 cm x 91 cm)
Plywood

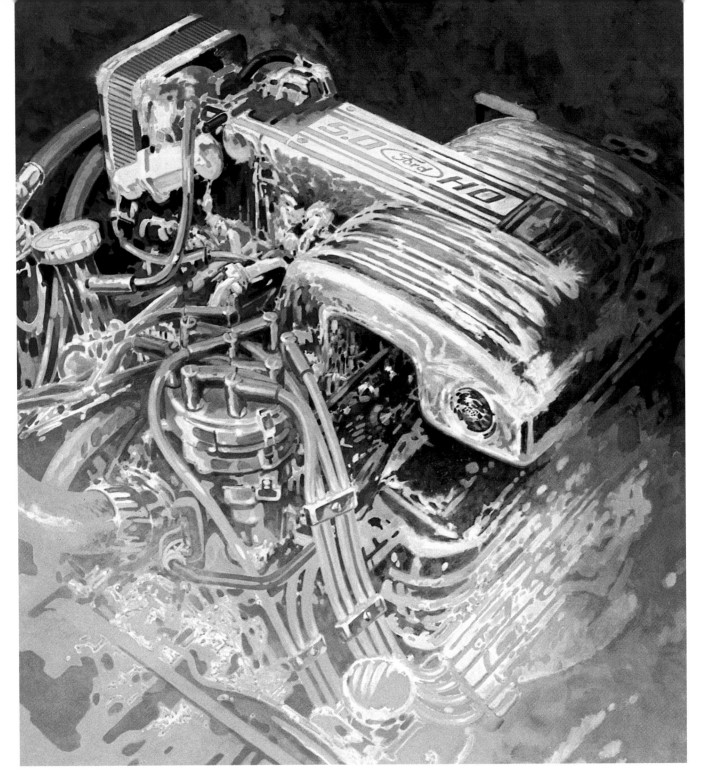

Don Getz
Blue Thunder
48" x 40" (122 cm x 102 cm)
Masonite untempered gesso-coated .25" board

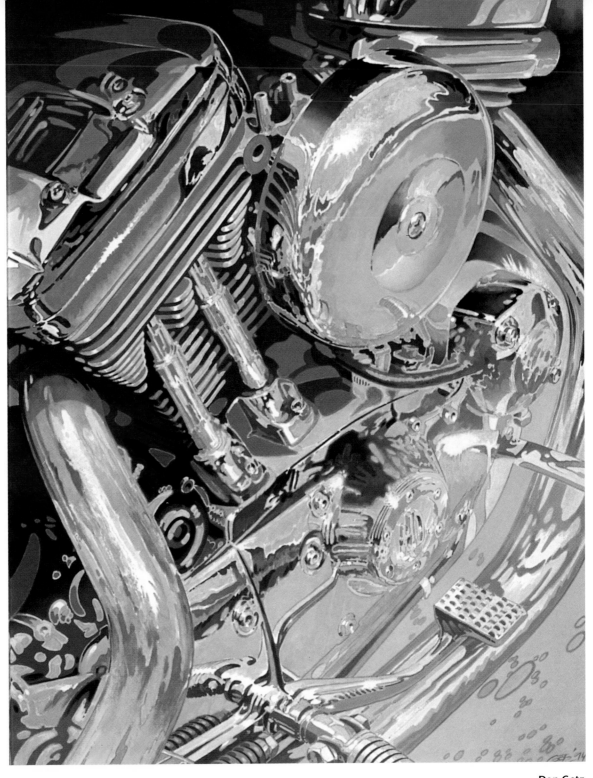

Don Getz
Sebring Challenge
36" x 24" (91 cm x 61 cm)
Grumbacher Hypro gesso-coated paper

87

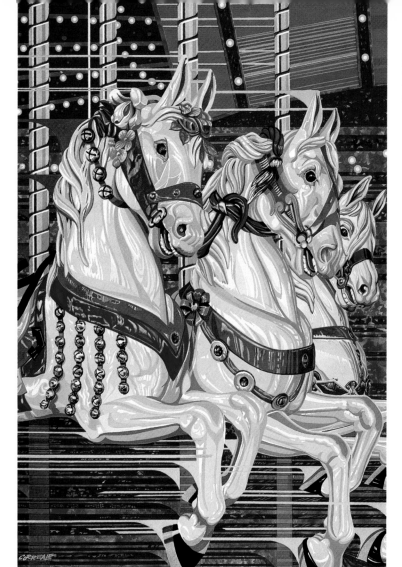

Joseph J. Correale, Jr.
Carousel Dream
40" x 30" (102 cm x 76 cm)
Canvas

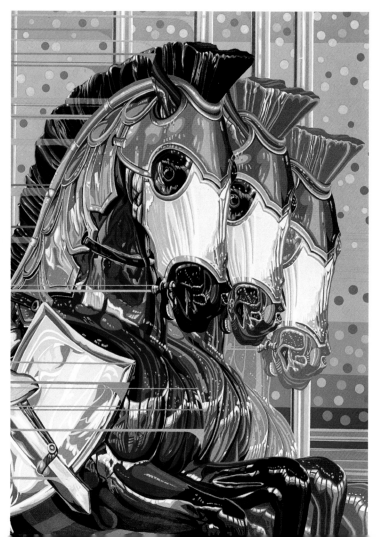

Joseph J. Correale, Jr.
Horse of a Different Color
40" x 30" (102 cm x 76 cm)
Canvas

Joseph J. Correale, Jr.
Up, Up & Away
40" x 30" (102 cm x 76 cm)
Canvas

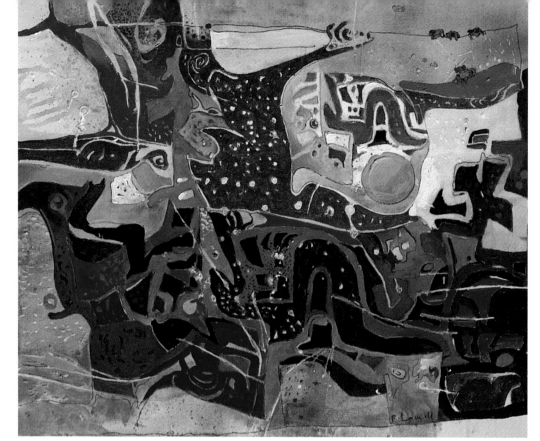

Robert Lamell
Aahscape
20" x 24" (51 cm x 61 cm)
Canvas

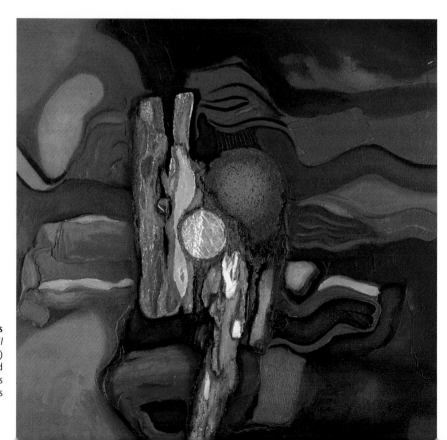

Atanas Karpeles
Yantra II
48" x 48" (122 cm x 122 cm)
Acrylic with bark, polished
stone, foil, and plastic balls
Cotton canvas

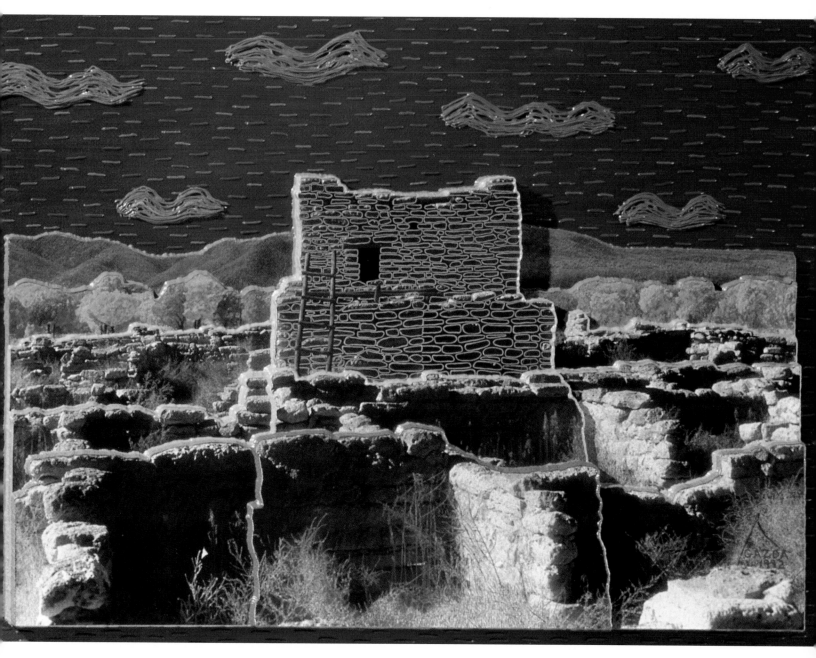

Paul Gazda
Second Pueblo
22" x 30" (55 cm x 75 cm)
Acrylic with black-and-white photographs
Foam board on canvas

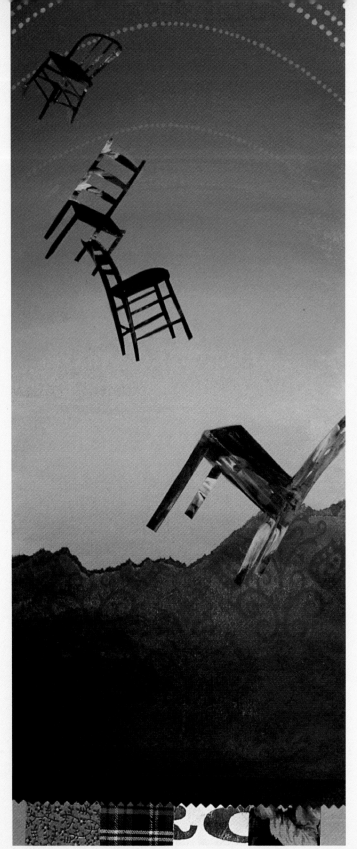

Nancy Smith
Sindi's Cabin
23" x 12" (58 cm x 30 cm)
Acrylic with cut paper
Cold press illustration board

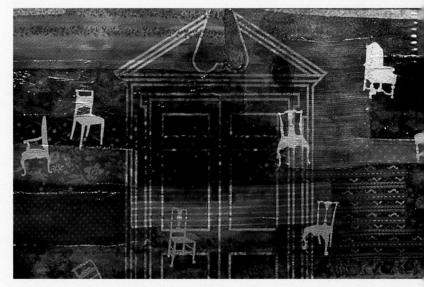

Ed Brodkin
Well Met.
36" x 60" (91 cm x 152 cm)
Acrylic with spray enamel
Printed and woven fabrics
mounted on wood panel

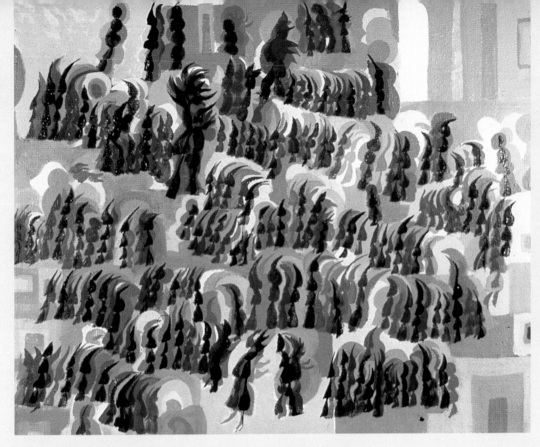

Winston Hough
Queue For Queen Mother
43" x 53" (109 cm x 135 cm)
Canvas

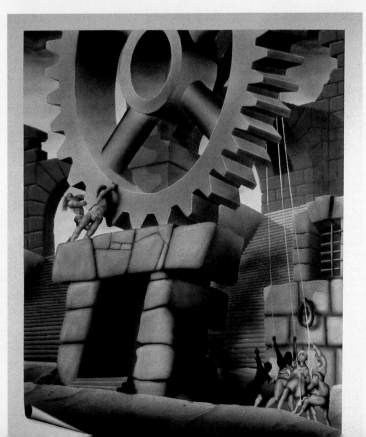

Jeffrey P. Flower
Old Habits Are Hard to Break,
Gear Series 1/3
66" x 48" (166 cm x 122 cm)
Acrylic and white house paint
Wood

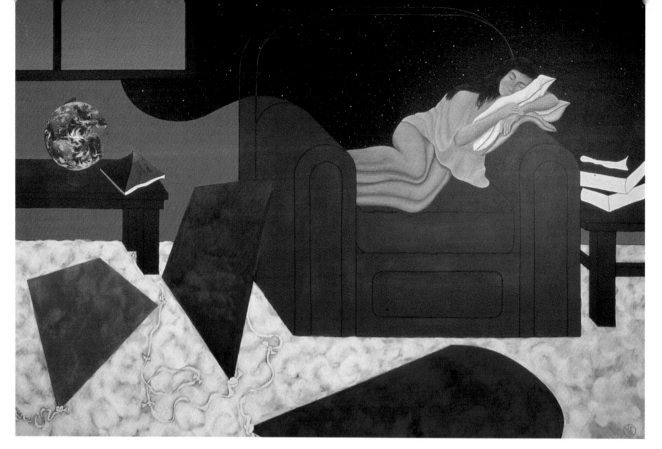

Porter A. Lewis
Celestial Snooze
48" x 68" (122 cm x 173 cm)
Canvas

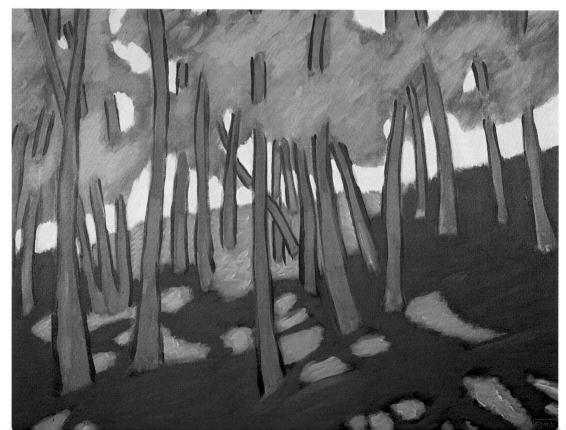

Ellen McCormick Martens
Dancing Trees
22" x 28" (56 cm x 71 cm)
Gesso-coated canvas

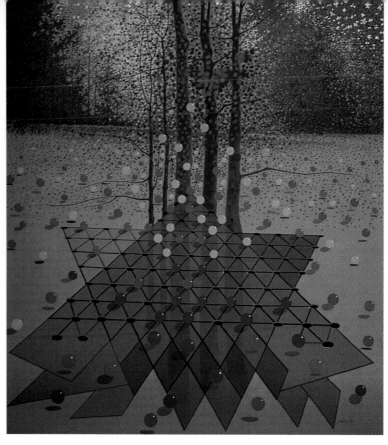

Rolland Golden
The Power of Relativity
48" x 36" (122 cm x 91 cm)
Canvas

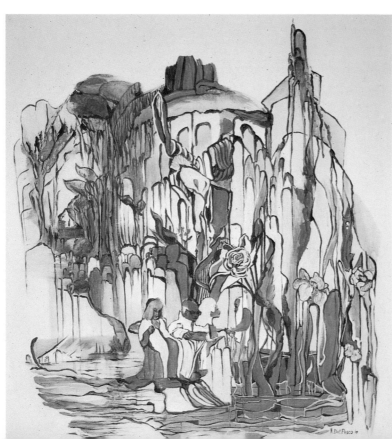

Nancy Del Pesco/Thornton
Waiting for Paradise
54" x 54" (137 cm x 137 cm)
Canvas

95

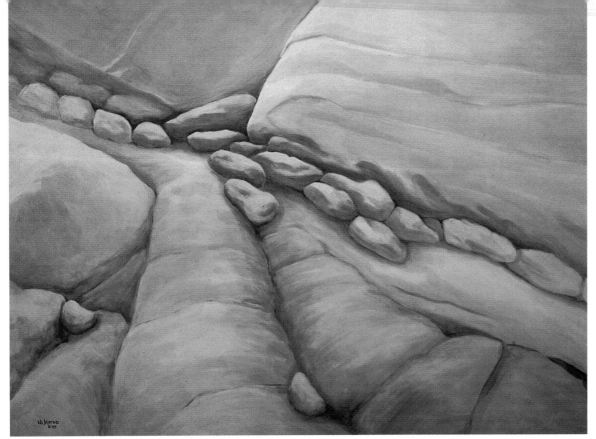

N. L. Matus
Terra III
Photo by Marilyn Szabo
36" x 48" (91 cm x 122 cm)
Canvas

N. L. Matus
Sanctuary
Photo by Marilyn Szabo
10" x 20" (25 cm x 51 cm)
Canvas

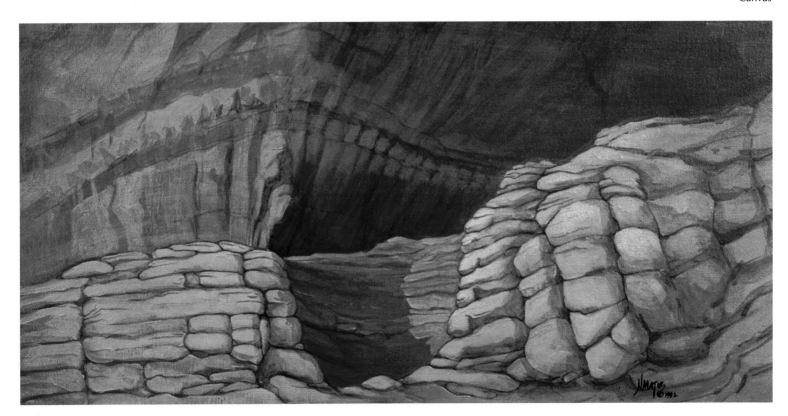

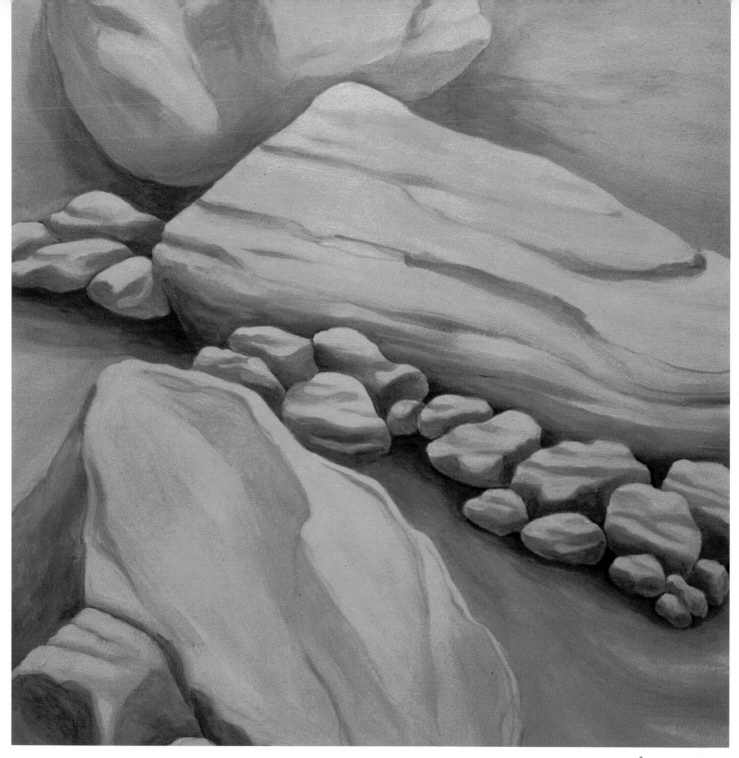

N. L. Matus
Flux
Photo by Marilyn Szabo
36" x 36" (91 cm x 91 cm)
Canvas

Susan Lucas Updyke
Dune Grasses VI
22" x 30" (56 cm x 76 cm)
Strathmore Aquarius

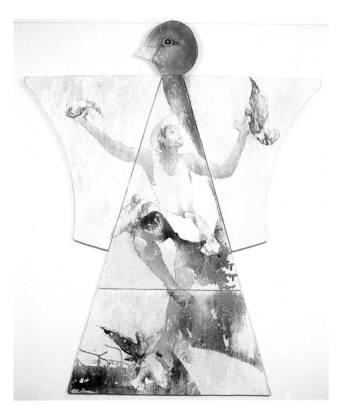

Doris Price
Birdflight
80" x 70" (203 cm x 178 cm)
Gatorboard sand- and
gesso-coated foam core board

Atanas Karpeles
Repose
30" x 23" (76 cm x 59 cm)
Acrylic with pastel
Arches 300 lb. paper

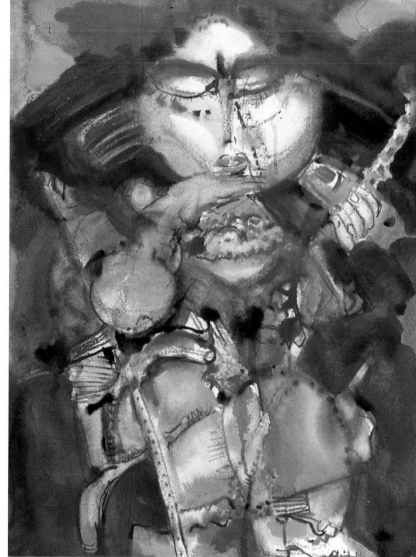

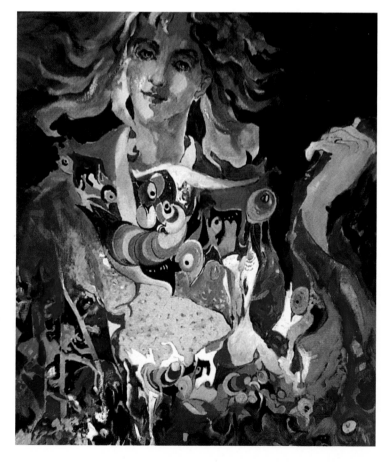

Robert Lamell
Pythia
30" x 24" (78 cm x 61 cm)
Canvas

Jodi Cohen
Dreamland
52" x 52" (132 cm x 132 cm)
Canvas

Jodi Cohen
The Nuclear Family
50" x 50" (127 cm x 127 cm)
Canvas

Anne Bagby
Queens Diamond
20" x 20" (50 cm x 50 cm)
Canvas

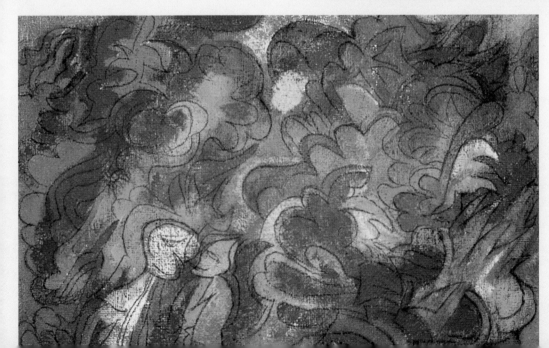

Winston Hough
Evening Outing
25" x 37" (64 cm x 94 cm)
Acrylic with charcoal
Burlap mounted on Masonite board

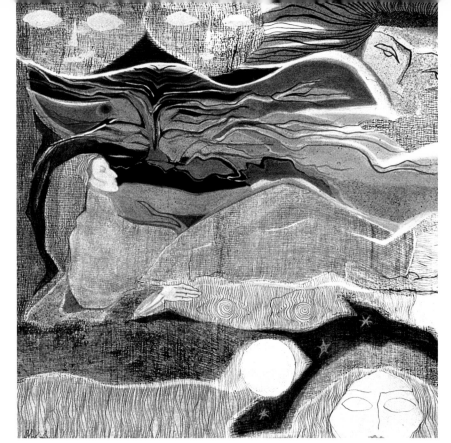

Alex Andra
Reveries I
37" x 37" (94 cm x 94 cm)
Canvas

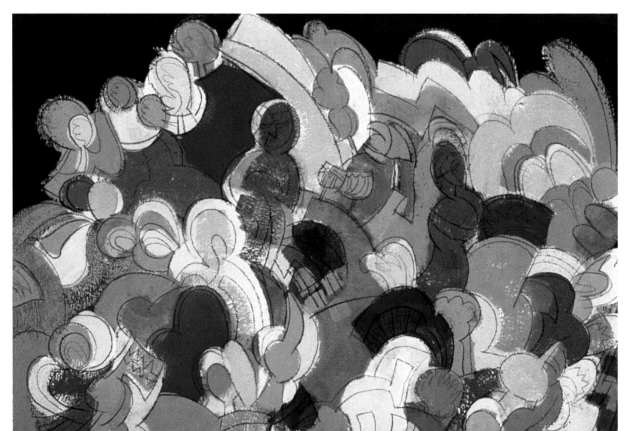

Winston Hough
Goin'
30" x 42" (76 cm x 107 cm)
Acrylic with charcoal
Canvas

102

Lloyd Bakan
Celebration
40" x 30" (102 cm x 76 cm)
Arches 140 lb. paper

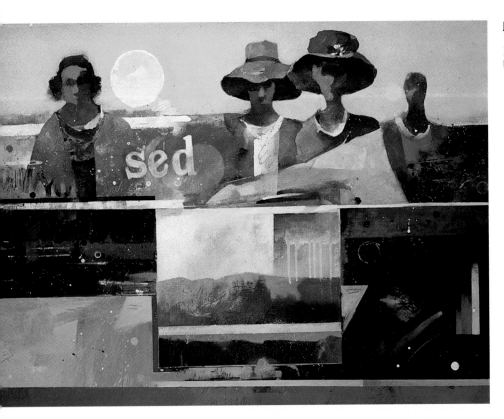

Jorge Bowenforbés
Yesterday's Women
30" x 40" (76 cm x 102 cm)
Illustration board

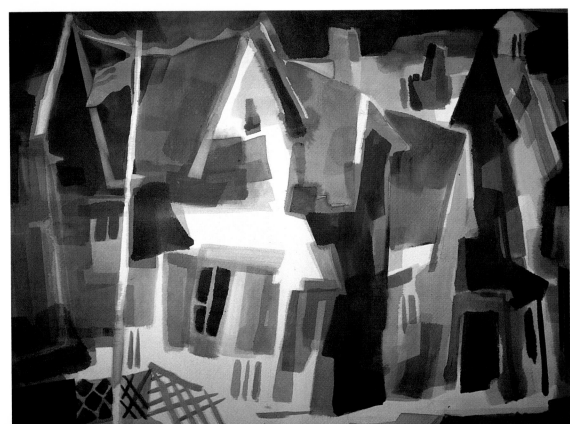

S. Webb Tregay
I Grew Up Surrounded by Republicans
39" x 49" (99 cm x 125 cm)
Unprimed canvas

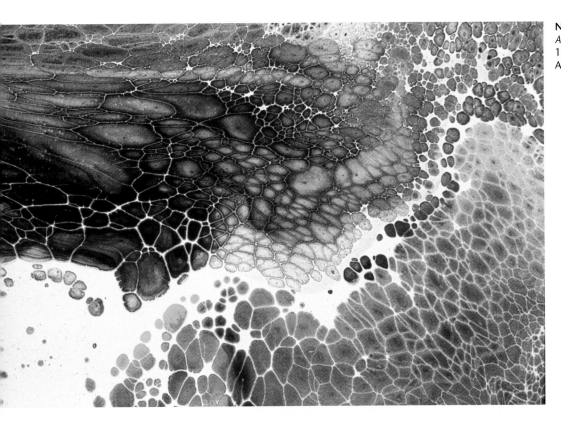

Naomi Marks Cohan
Another Place...Another Time
14.5" x 14.5" (37 cm x 37 cm)
Arches 140 lb. cold press

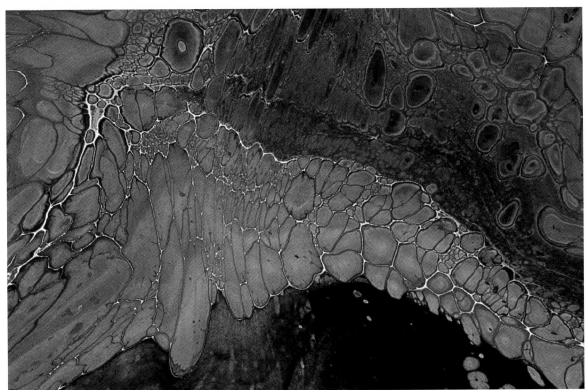

Naomi Marks Cohan
Spring Patterns
10.5" x 14" (27 cm x 36 cm)
Arches 140 lb. cold press

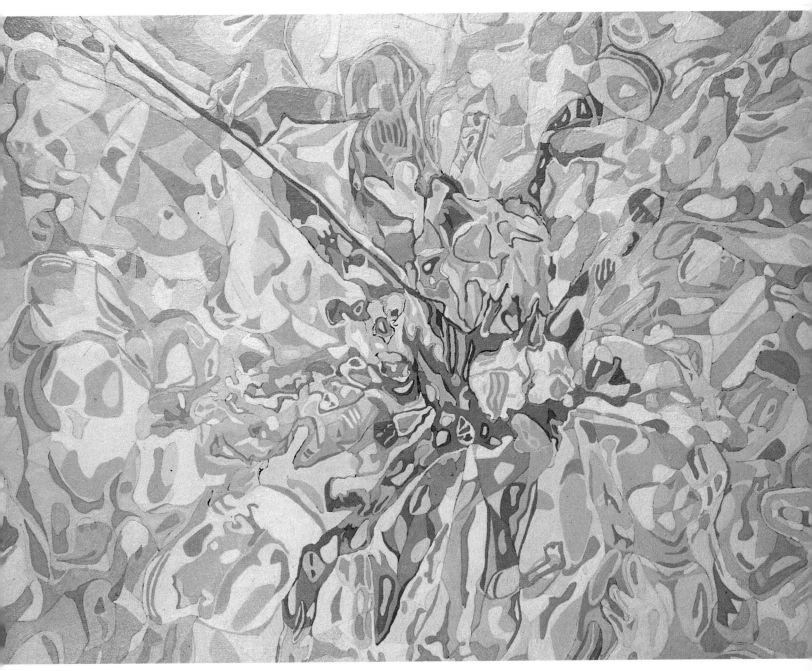

Denise Carey
The Bud
18" x 24" (46 cm x 61 cm)
Masonite 100% rag rice paper-
covered gesso-coated panel

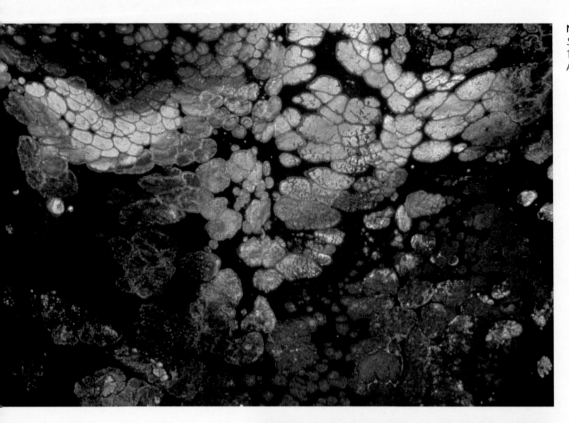

Naomi Marks Cohan
Suspended Flowers II
14" x 14" (36 cm x 36 cm)
Arches 140 lb. cold press

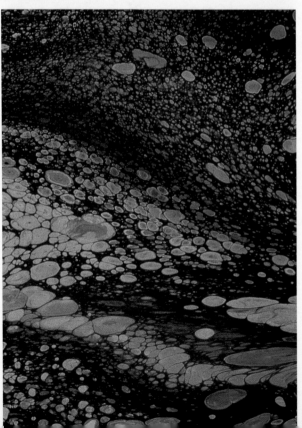

Naomi Marks Cohan
Autumn Twilight
13.5" x 12.5" (34 cm x 32 cm)
Arches 140 lb. cold press

Atanas Karpeles
Symmetry
30" x 23"
(76 cm x 59 cm)
Arches 300 lb. paper

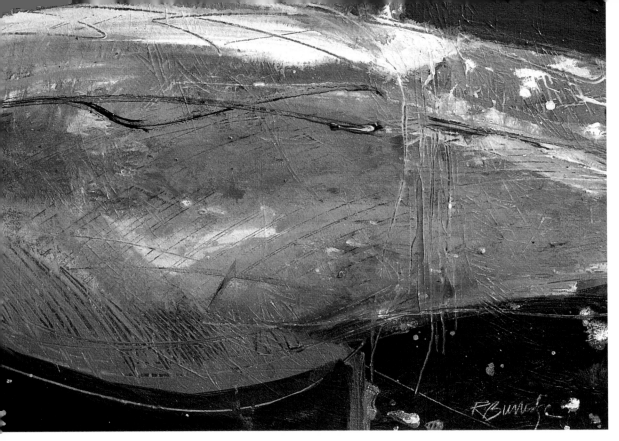

Robert Burridge
Landescape
22" x 30" (56 cm x 76 cm)
Lana Aquarelle 180 lb.
hot press paper

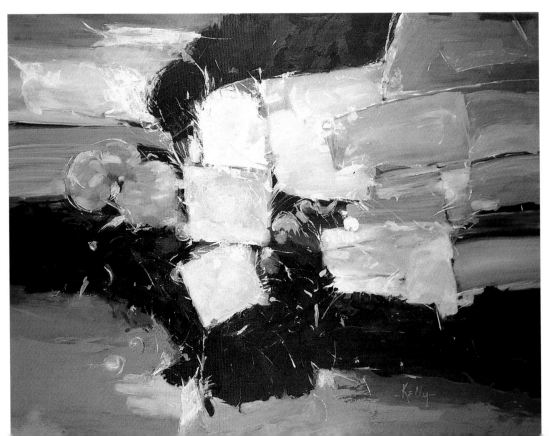

Joan D. Kelly
The Walls Come Tumbling Down
48" x 60" (121 cm x 151 cm)
Canvas

Marsh Nelson
Greener Fields
31" x 39" (79 cm x 99 cm)
Two-ply museum board

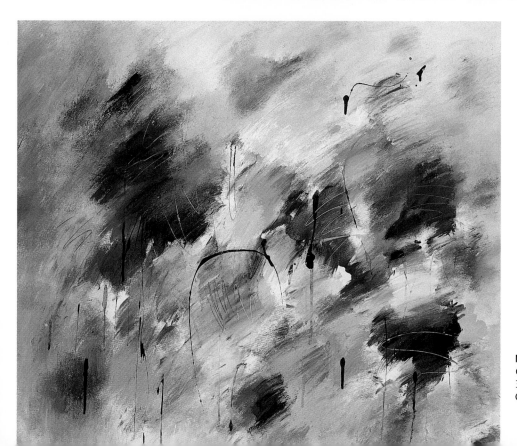

Meyer Tannenbaum
Gesture Calligraphic No. 33
36" x 40" (91 cm x 102 cm)
Canvas

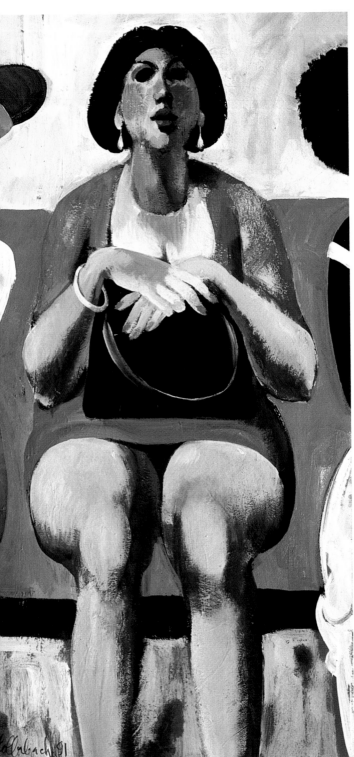

Serge Hollerbach
Woman in Green Dress
40" x 20" (102 cm x 51 cm)
Paper on cold press
illustration board

Serge Hollerbach
Two Women and Child
33" x 26" (84 cm x 66 cm)
Paper on cold-press
illustration board

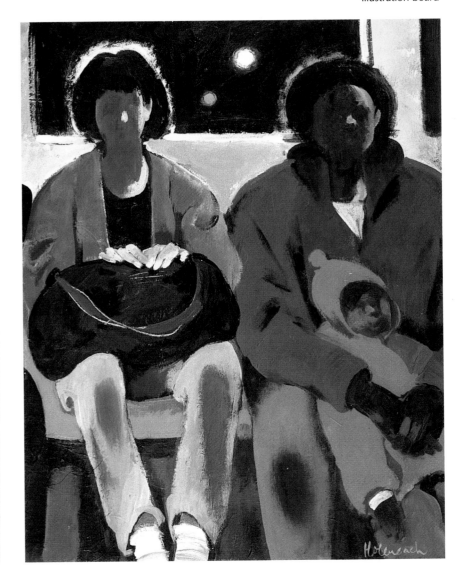

Nydia Preede
Positive Approach to
Color Integration
24" x 18" (61 cm x 46 cm)
Canvas

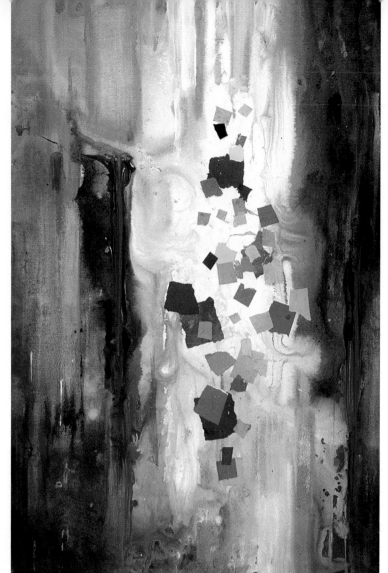

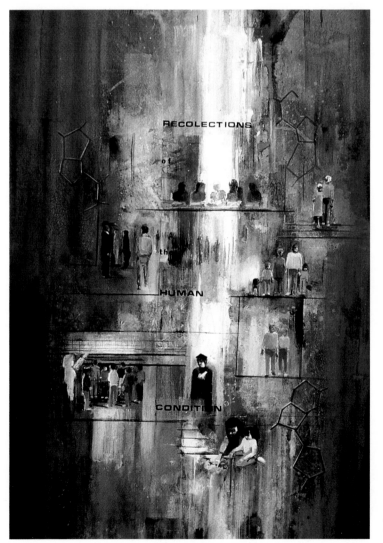

Nydia Preede
Recollections of the Human Condition
40" x 30" (102 cm x 76 cm)
Board

Claffy Williams
Night Grasses
30" x 66"
(76 cm x 168 cm)
Canvas

Claffy Williams
Kala (A Weather
God in India)
36" x 66"
(91 cm x 168 cm)
Canvas

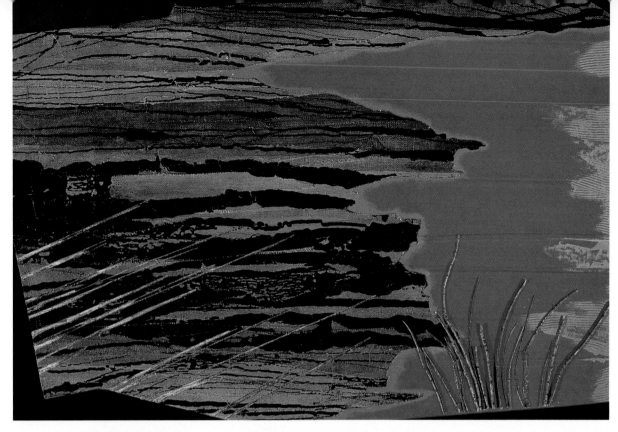

Ed Brodkin
Millstone Valley
38" x 58"
(97 cm x 148 cm)
Acrylic with polyurethane
Burlap and canvas
on wood panel

Claffy Williams
*Waka (Goddess of
Food in Japan)*
28" x 54"
(71 cm x 137 cm)
Canvas

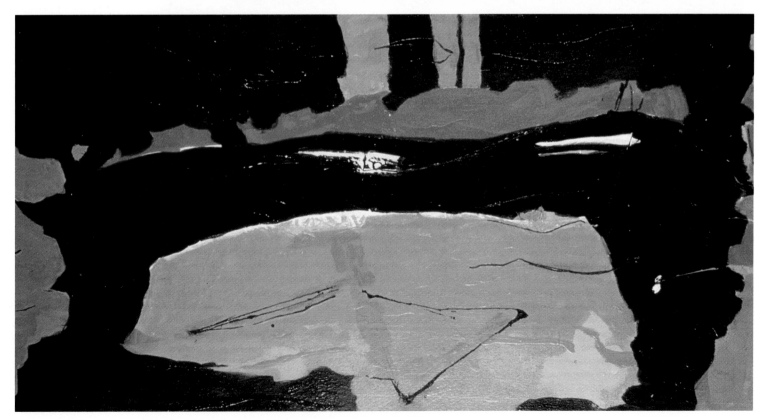

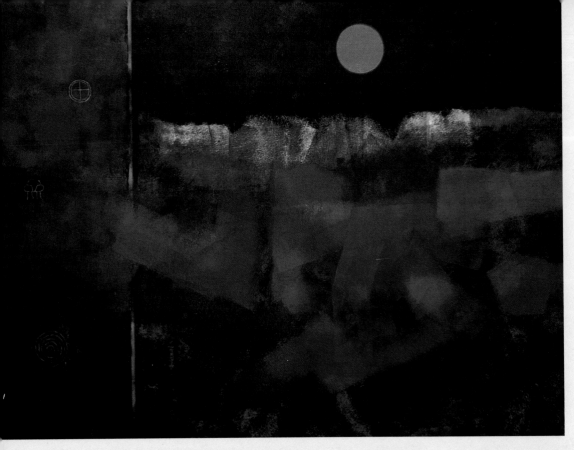

John Casey
Kylotsmovi
36" x 48" (92 cm x 121 cm)
Board

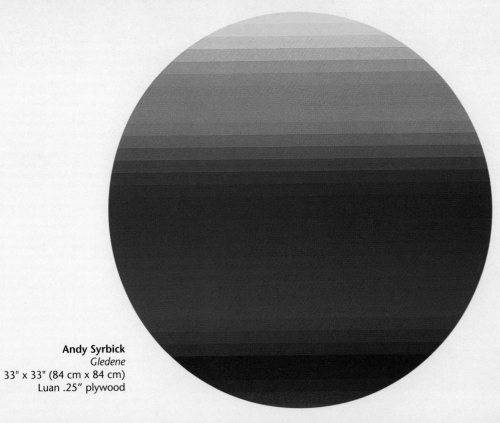

Andy Syrbick
Gledene
33" x 33" (84 cm x 84 cm)
Luan .25" plywood

Dennis Green
Mixed Signals
30" x 24" (75 cm x 60 cm)
Paper on wood

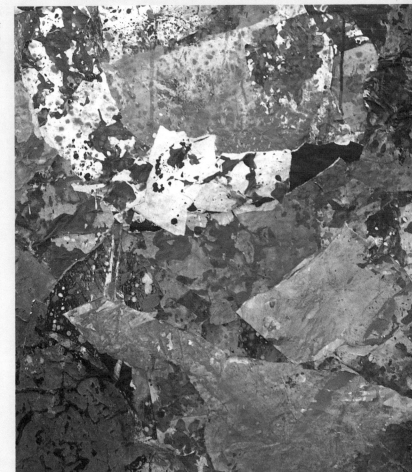

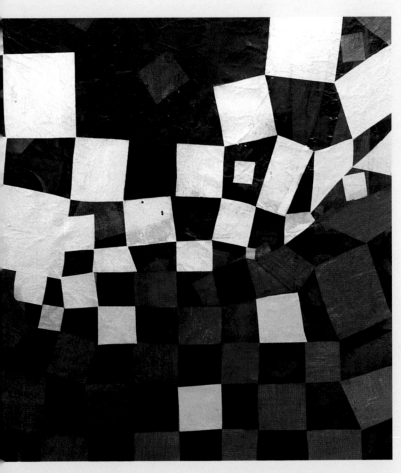

Dennis Green
Harmonica
52" x 50" (130 cm x 125 cm)
Paper on canvas

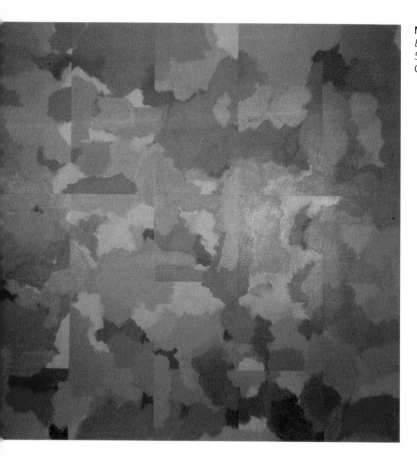

Meyer Tannenbaum
Bright Clouds
50" x 50" (127 cm x 127 cm)
Canvas

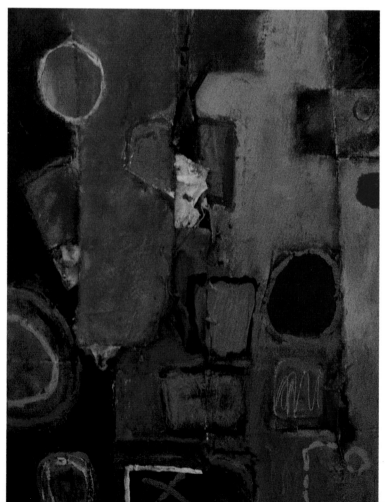

Joan Painter Jones
Torn Quilt #2
25" x 19" (63 cm x 48 cm)
Acrylic with cloth and wood
Canvas

Edith Socolow
Window Series-Eve Tides
28" x 38" (71 cm x 97 cm)
Paper

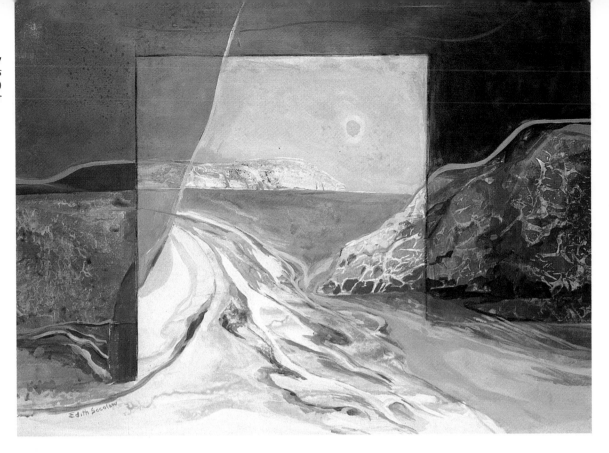

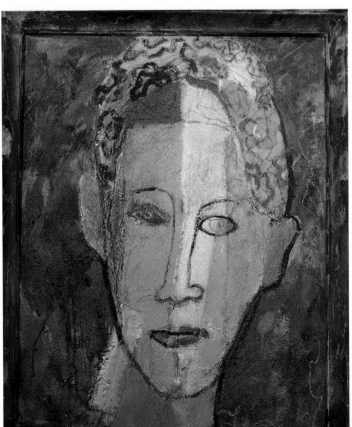

Joan Painter Jones
Woman/Hat
24" x 20" (60 cm x 50 cm)
Canvas board

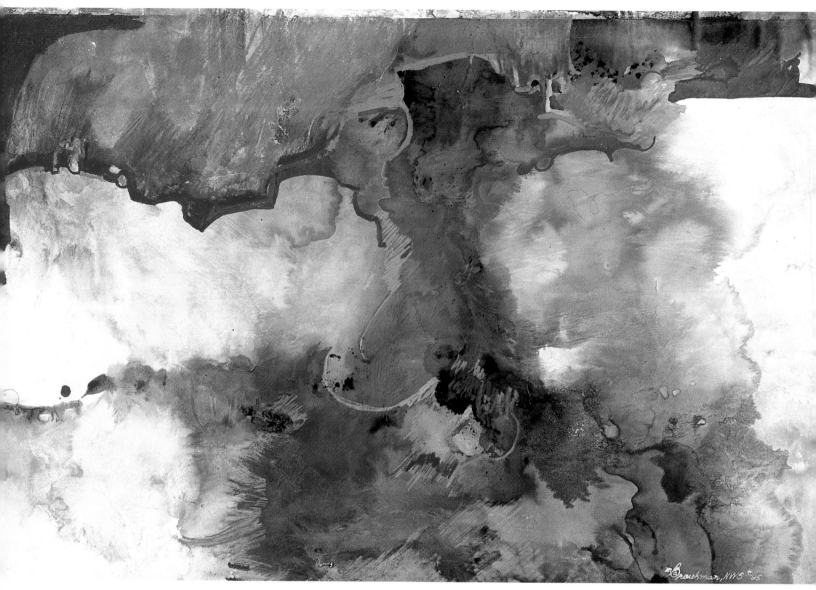

Mary Alice Braukman
Cloud Turbulence
18" x 28" (46 cm x 71 cm)
Acrylic with gesso, absorbent
ground, and crayon
Strathmore #500 gesso-coated
heavy-weight plate surface paper

Mary Alice Braukman
Kindred Creatures
22" x 30" (56 cm x 76 cm)
Acrylic with pastel
T.H. Saunders 300 lb.
cold press paper

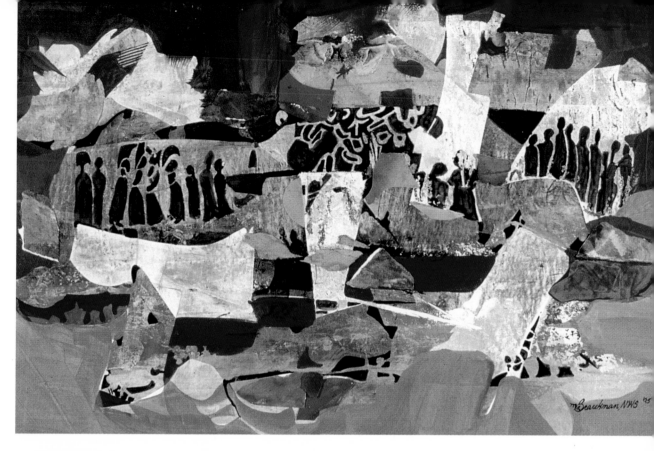

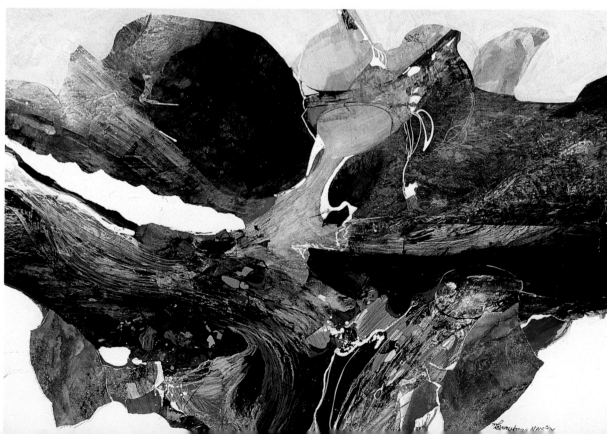

Mary Alice Braukman
Eroded Rocks
22" x 30" (56 cm x 76 cm)
Acrylic with gesso, inks,
watercolor pencil, and
watercolor crayon
Fabriano 300 lb. hot press

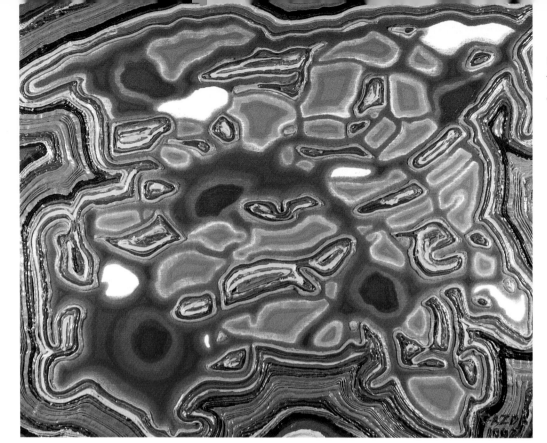

Paul Gazda
Archipelago
18" x 22" (45 cm x 55 cm)
Canvas

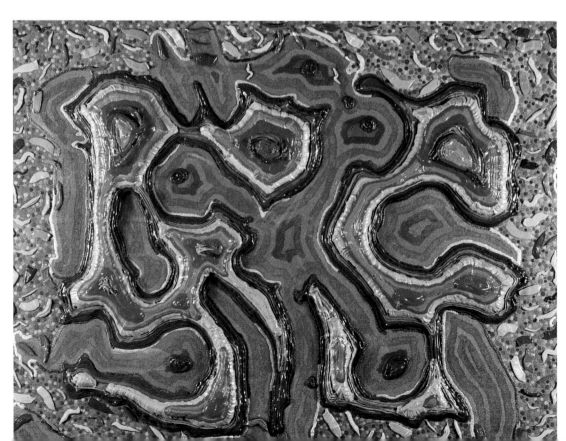

Paul Gazda
Overhead View
14" x 18" (35 cm x 45 cm)
Acrylic with modeling
paste and glaze
Canvas

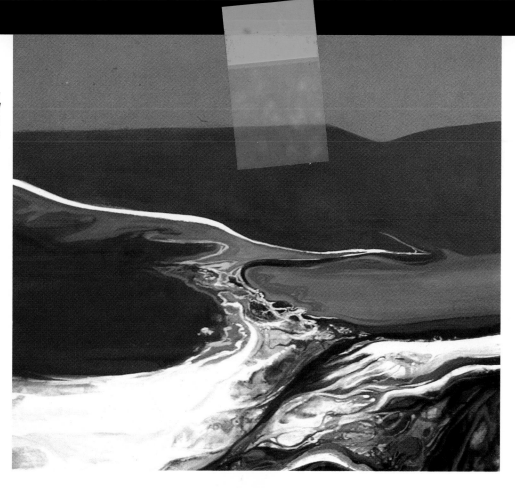

Edith Socolow
Night on Salt Island
29" x 36" (74 cm x 91 cm)
Canvas

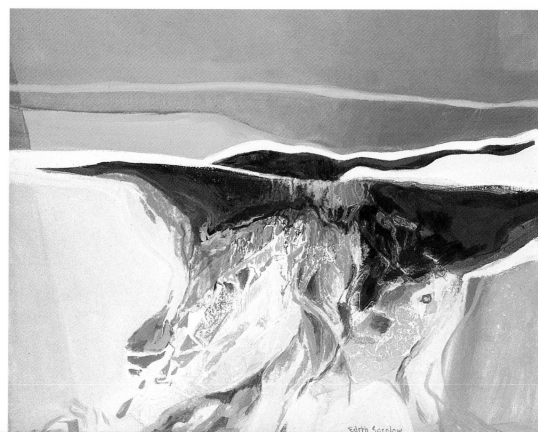

Edith Socolow
Receding Tides
21" x 25" (54 cm x 64 cm)
Canvas

Kathy Stark
Reflections on a Pond
29" x 61" (74 cm x 155 cm)
Canvas

Kathy Stark
An Ever Changing View
27" x 45"
(69 cm x 114 cm)
Canvas

Kathy Stark
A Woman Sitting Comfortably
with her Ambivalence
41" x 31" (104 cm x 79 cm)
Canvas

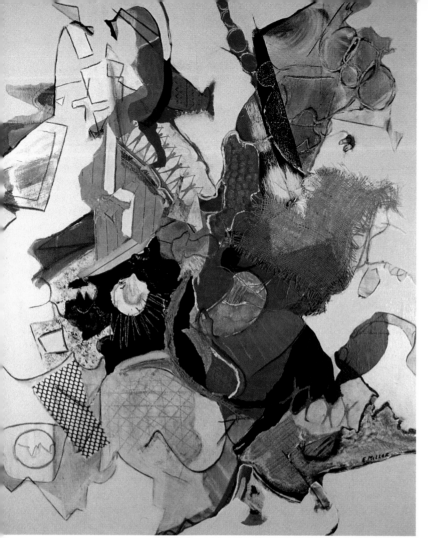

Elaine S. Miller
Unity
41" x 33" (104 cm x 84 cm)
Acrylic with wire mesh, paper, and burlap
Gesso-coated linen canvas

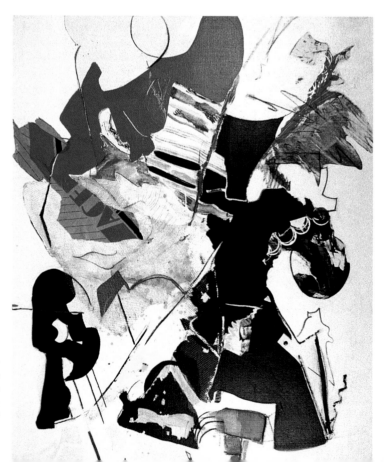

Elaine S. Miller
Chivalry
50" x 40" (127 cm x 102 cm)
Acrylic with plastic mesh
Gesso-coated linen canvas

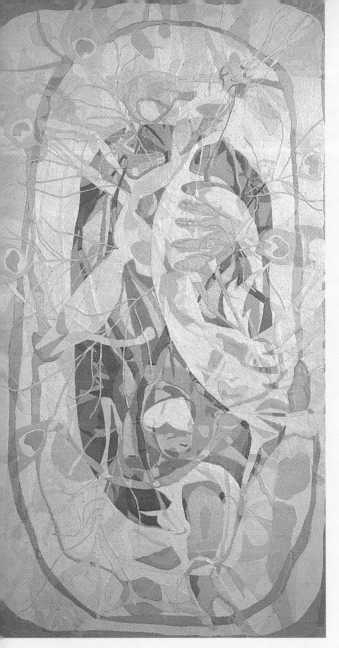

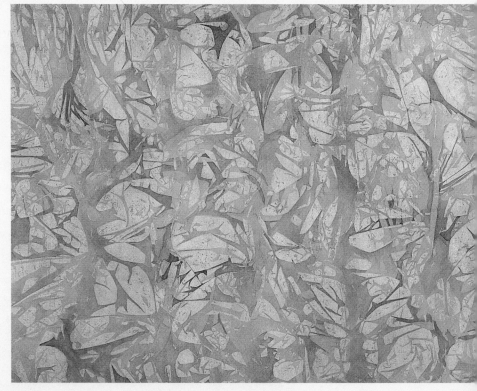

Sandra I. Fraser
Forest Primitives
33" x 46" (84 cm x 117 cm)
Acrylic with gesso
Grumbacher Hypro 300 lb. paper

Denise Carey
Slaying of the Peacock
36" x 20" (91 cm x 51 cm)
Masonite 100% rag rice paper-covered board

Alice Laputka
Ancient City
21" x 29" (53 cm x 74 cm)
Acrylic with oriental paper
and paste paper
Arches 140 lb. hot press
watercolor paper

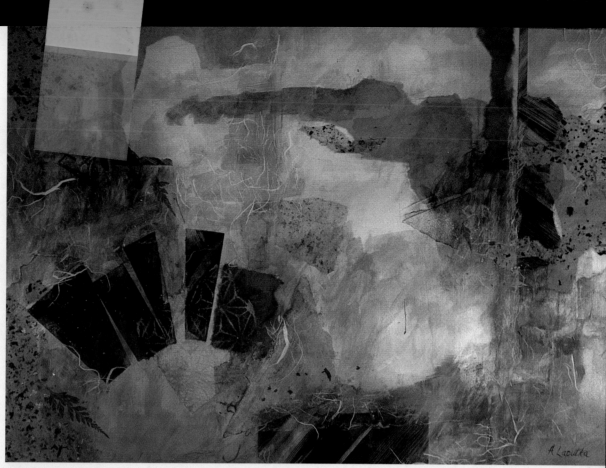

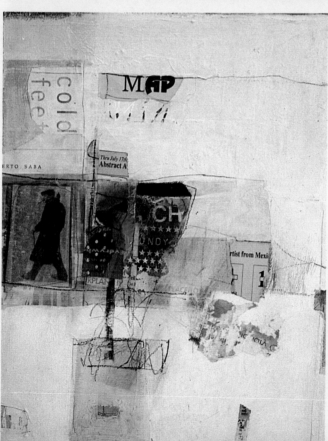

Katherine Chang Liu
Cold Feet
22" x 16" (56 cm x 41 cm)
300 lb. Hot press paper

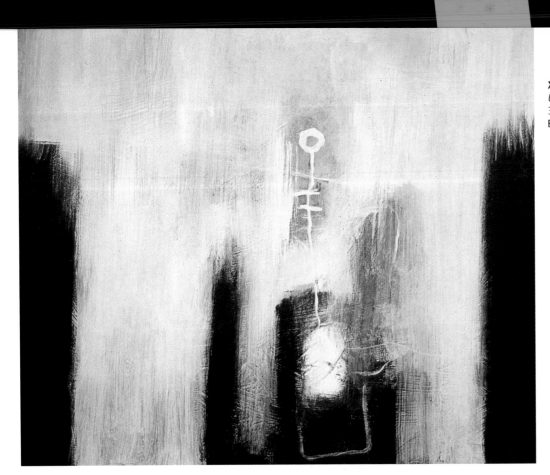

Xu Bei
U.S. Diary No. 4
32" x 48" (81 cm x 122 cm)
Board

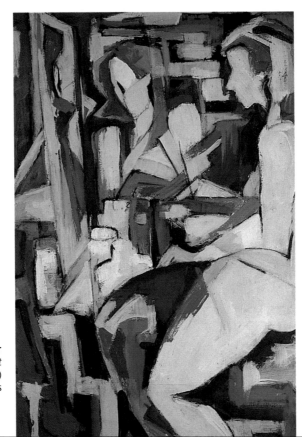

Jeannette Harris Heiberger
Self Portrait
47" x 32" (119 cm x 81 cm)
Cotton canvas

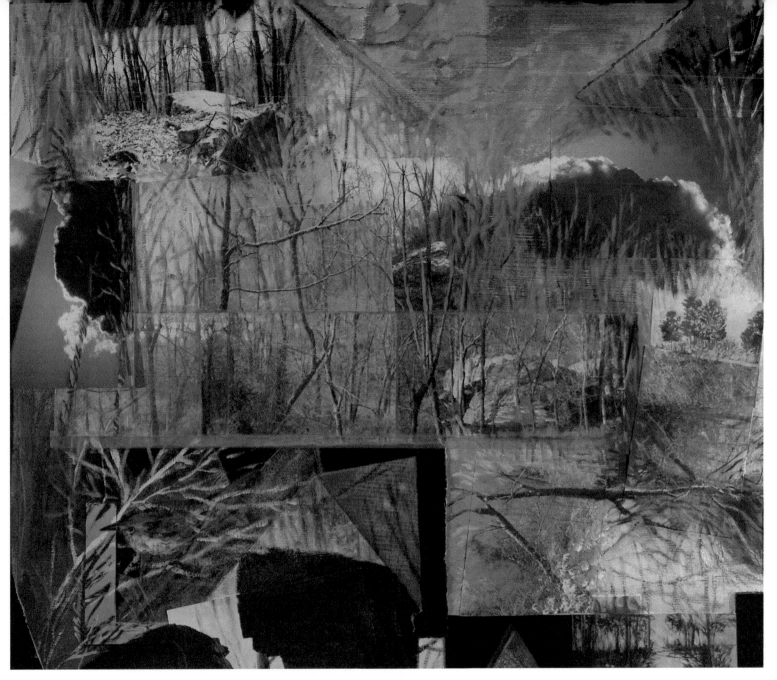

Mary Britten Lynch
Eternal Rhythms
30" x 30" (76 cm x 76 cm)
Arches 300 lb. cold press

Susan Wrona Gall
Diozanine Sun
24" x 42" (61 cm x 107 cm)
Acrylic with silica sand
Aluminum

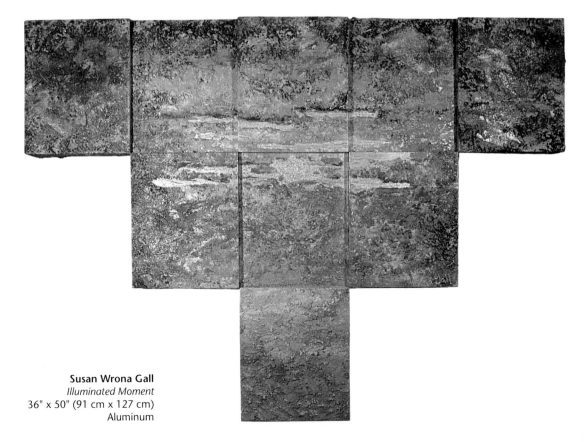

Susan Wrona Gall
Illuminated Moment
36" x 50" (91 cm x 127 cm)
Aluminum

Leslie Masters
Mountain Rust
34" x 22" (88 cm x 57 cm)
Acrylic metal plate and barbed wire
Metal plate on stretched and
gesso-coated cotton canvas

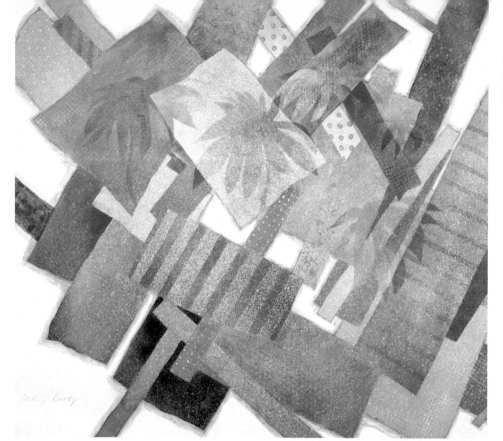

Carol Z. Brody
Party Papers V
30" x 22" (76 cm x 56 cm)
Lana Aquarelle 140 lb. paper

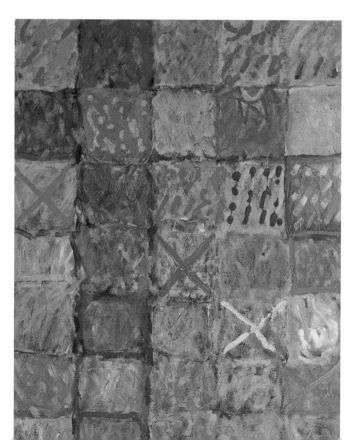

Joan Painter Jones
Hope Quilt #1
30" x 23" (81 cm x 58 cm)
Arches 300 lb. paper

Alex Andra
Drifting
45" x 65" (114 cm x 165 cm)
Arches 300 lb. paper

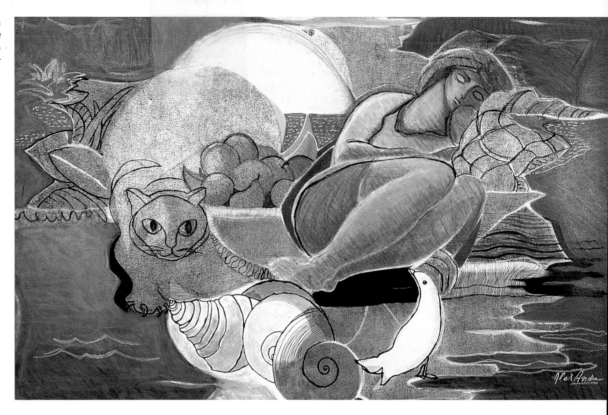

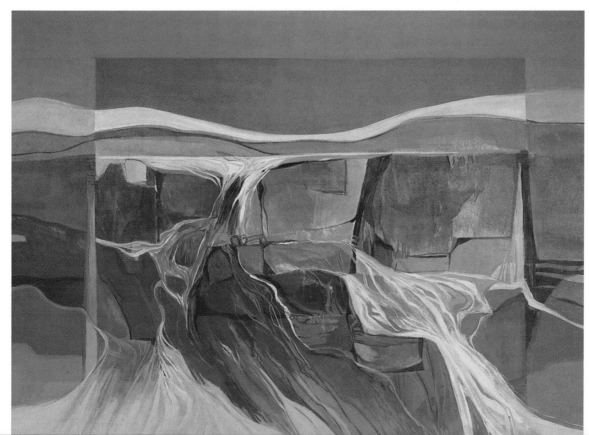

Edith Socolow
Window Series-Spring Thaw
38" x 49" (97 cm x 124 cm)
Canvas

135

Marge Mills
Untitled
24" x 40" (61 cm x 102 cm)
Canvas

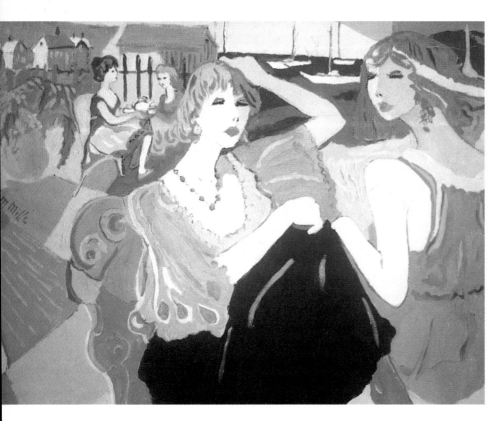

Marge Mills
Untitled
24" x 30" (61 cm x 76 cm)
Canvas

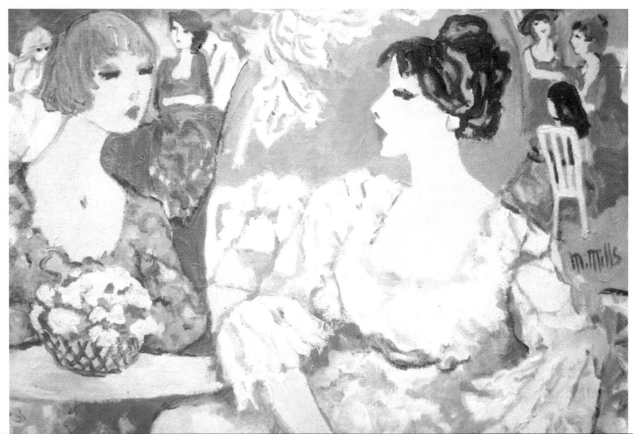

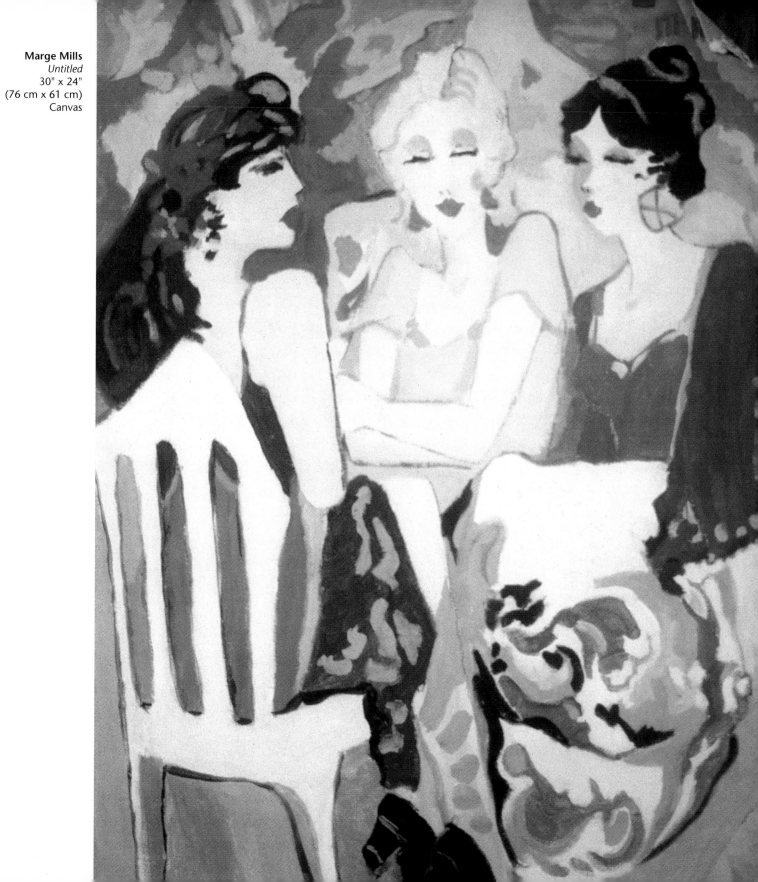

Marge Mills
Untitled
30" x 24"
(76 cm x 61 cm)
Canvas

Sally Linder
Butterflies are a Good Omen
27" x 43" (69 cm x 109 cm)
Stonehenge paper

Jay Havighurst
Untitled
54.5" x 44" (138 cm x 112 cm)
Canvas

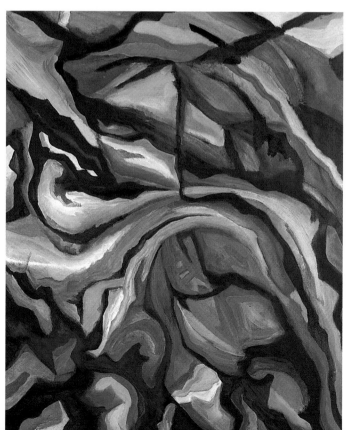

138

M. B. Bercaw
Wonder
24" x 18" (61 cm x 46 cm)
Four-ply white museum board

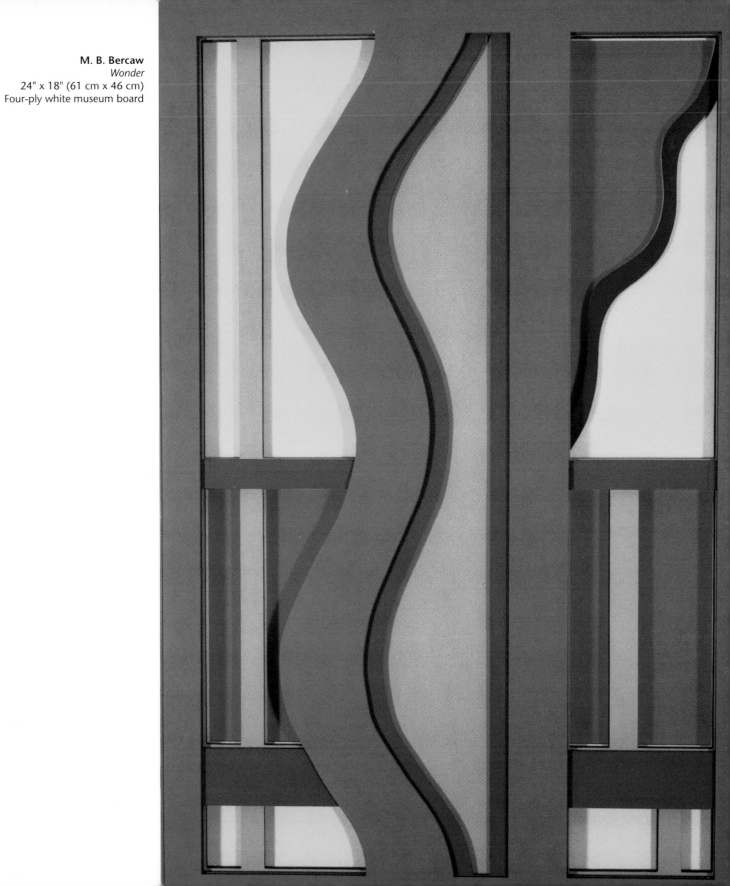

Marian Hettner Grunbaum
Light and Shade
36" x 48" (91 cm x 122 cm)
Canvas

About the Judges

Alfred M. Duca has expanded the art world's horizons not only by producing beautiful and important pieces of art, but actually developing the processes and tools with which some art is made. He is the developer of the Polymer Tempera process that lead to the development of modern-day acrylic paint. He also is credited with the development of the Foam Vaporization Process for painting and sculpture. Duca studied at the Pratt Institute in New York City and at the Museum School in Boston. His major sculptural commissions include the *Boston Tapestry* at the Prudential Center and *Computersphere* at the JFK Post Office Building both in Boston, Massachusetts. The DeCordova Museum in Lincoln, Massachusetts and the Fogg Museum in Cambridge, Massachusetts, are among the places where Duca's works have been exhibited. He has received various grants and awards including a Lifetime Achievement Award from Michael Dukakis.

Lynn Loscutoff studied at California Art & Crafts, Art Institute, Boston, Montserrat School of Art, Massachusetts and has studied privately with noted artists Jason Berger, Sygmond Jankowski, and Betty Lou Schlemm. She is listed in *Who's Who in International Art, Who's Who in America,* and *Who's Who in the East.* Loscutoff loves to travel and paint, and has painted on site in China, Africa, Israel, Japan, France, England, Mexico, and throughout the United States. She is the recipient of the coveted Copley Medal for distinguished service to the arts (awarded only five times during the past century) and has served as the executive director of the Copley Society of Boston.

Loscutoff maintains studios in Gloucester, Massachusetts, Naples, Florida, and Carmel, California. Her work is collected and exhibited internationally.

Alfred M. Duca
Hearthstone
96" x 48" (144 cm x 122 cm)
Canvas

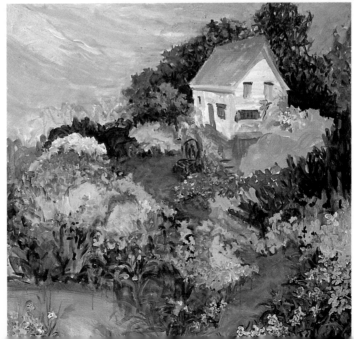

Lynn Leon Loscutoff
Day Lily Festival
48" x 48" (120 cm x 120 cm)
Canvas

Index

Directory

Laura Anderson
P. O. Box 105
Marion, MA 02738

Alex Andra
3206 Bluffs Drive
Largo, FL 34640

Lynda Andrews-Barry
Design Options
3509 Lawrence Avenue
Kensington, MD 20895

Christine F. Atkins
154 Minimine Street
Stafford. Queensland
AUSTRALIA. 4053

Steven L. Babecki
3774 Spinnaker Court
Fort Pierce, FL 34946

Anne Bagby
242 Shadowbrook
Winchester, TN 37398

Lloyd Bakan
1721 Second Street, #103
Sacramento, CA 95814

Dorothy Watkeys Barbaris
217 Lincoln Avenue
Elmwood Park, NJ 07407-2822

Jann T. Bass
2700-B Walnut Street
Denver, CO 80205

Gaye Elise Beda
317 Second Avenue, #16
New York, NY 10003

Xu Bei
5806 Johnson Avenue
Bethesda, MD 20817

M. B. Bercaw
104 Marti Court
Oxford, OH 45056

Janet C. Blagdon
54 Emerson Road
Needham, MA 02192

John Boomer
Crystal Pond Studio
Box 696
Navajo, NM 87328

Jorge Bowenforbés
P. O. Box 1821
Oakland, CA 94612

Mary Alice Braukman
636 19th Avenue NE
St. Petersburg, FL 33704

Ed Brodkin
167 Garden Avenue
Paramus, NJ 07652-5399

Carol Z. Brody
159 Fields Avenue
Staten Island, NY 10314

Gerald F. Brommer
11252 Valley Spring Lane
Studio City, CA 91602

Richard Brzozowski
13 Fox Road
Plainville, CT 06062

Leslie Lew Burns
604 Douglas Road
Chappaqua, NY 10514

Robert Burridge
1451 Paseo Ladera Lane
Arroyo Grande, CA 93420

Michael R. Canter
3554 Woolworth Avenue
Omaha, NE 68105

Elaine Caramagna
1 Beach Street
Beverly Farms, MA 01915

Denise Carey
4023 Kakini Road
Oroville, CA 95965

Gordon Carlisle
P. O. Box 464
Portsmouth, NH 03802-0464

John Casey
2095 Oak Grove Road NW
Salem, OR 97304

Naomi Marks Cohan
3104 Morley Road
Shaker Heights, OH 44122

Jodi Cohen
322 West 104th Street, #3F
New York, NY 10025

Joseph J. Correale, Jr.
Correale Gallery
25 Dock Square
Rockport, MA 01935

Nancy Del Pesco/Thornton
Del Pesco Fine Arts
1335 South Carmelina Avenue, #103
Los Angeles, CA 90025

Phyllis A. De Sio
De Sio Fine Arts
541 Revere Avenue
Westmont, IL 60559

John de Soto
369 Boxwood Drive
Shirley, NY 11967

DJ Donovan-Johnson
Contemporary Oils, Watermedia
225 Bristlecome Way
Boulder, CO 80304

Alfred Duca
8 Arlington Street
Gloucester, MA 01930

Mark Elder
2210 North Racine, 3R
Chicago, IL 60614

Reneé Emanuel
Rural Route 6, Box 6427
Moscow, PA 18444

Judith Futral Evans
34 Plaza Street
Apartment 808
Brooklyn, NY 11238

Bonnie Fergus
67 Grandview Beach Road
Indian River, MI 49749

Sidney Findling
75 Montgomery Street, 17A
New York, NY 10002

Patrick Fiore
4845 Winchester Drive
Sarasota, FL 34234

Tim Flanagan
Rural Route 1, Box 999
East Holden, ME 04429

Jeffrey P. Flower
576 North First, #5
San Jose, CA 95112

Sandra I. Fraser
6502 North Camino Katrina
Tucson, AZ 85718

Steven Ellis Frenkel
9695 North Pond Circle
Roswell, GA 30076-2914

Susan Wrona Gall
321 South Sangamon Street
Chicago, IL 60607

Betsy Gay
51 Round Hill Road
Armond, NY 10504

Paul Gazda
P. O. Box 10503
Sedona, AZ 86339

Don Getz
2245 Major Road
Peninsula, OH 44264-9626

Johanne M. Gimbrone
710 Potomac Avenue, #16
Buffalo, NY 14222-1244

Mark Lee Goldberg
918 North La Jolla Avenue
Los Angeles, CA 90046

Rolland Golden
78207 Woods Hole Lane
Folsom, LA 70437

Dennis Green
75 Hudson Avenue
Brooklyn, NY 11201

Marian Hettner Grunbaum
1 McKnight Place
Apartment 330
St. Louis, MO 63124

Elsie K. Harris
1043 Heather Hills Lane
Lexington, KY 40511

Jay Havighurst
10 Winthrop Street
Essex, MA 01929

Jeannette Harris Heiberger
10007 Portland Road
Silver Spring, MD 20901

Don Henson
Tamarack Studios
P. O. Box 453
Manistique, MI 49854

Serge Hollerbach
304 West 75th Street
New York, NY 10023

Winston Hough
937 Echo Lane
Glenview, IL 60025

Donald G. Jones
6812 Sandlewood Drive
Oklahoma City, OK 73132

Joan Painter Jones
7050 Talladay
Milan, MI 48160

Atanas Karpeles
Atanas Karpeles Fine Art
1766 East Vistillas Road
Altadena, CA 91001

Joan D. Kelly
5611 Brandon Boulevard
Virginia Beach, VA 23464-6503

Rachael Kennedy
680 Woodshire
Naples, FL 33942

Linda Kessler
54 Orange Street, #4-H
Brooklyn, NY 11201

Ann Kromer
40 Beechwood Lane
Ridgefield, CT 06877

Robert Lamell
2640 Wilshire Boulevard
Oklahoma City, OK 73116

Carolyn Parker Lamunière
239 Dill Avenue
Frederick, MD 21701

Valentina Landin
P. O. Box 72
Palm Desert, CA 92261

Ellen Westendorf Lane
12600 Hatteras Street
Valley Village, CA 91607

Alice Laputka
P. O. Box 25
Conyngham, PA 18219-0025

A. M. Lawtey
P. O. Box 5219
Edgartown, MA 02539

Christopher Leeper
4263 Lake Road
Youngstown, OH 44511

Dori Grace U. Lemeh
210 Patterson Building
University Park, PA 16802-5401

Porter A. Lewis
3845 35th West
Seattle, WA 98199

Sally Linder
122 Summit Street
Burlington, VT 05401

Petr Liska
13514 Grenoble Drive
Rockville, MD 20853

Katherine Chang Liu
1338 Heritage Plave
Westlake Village, CA 91362

Carol Lopatin
105 North Union Street
Alexandria, VA 22314

Lynn Leon Loscutoff
84 Langford Street
Gloucester, MA 01930

Mary Britten Lynch
1505 Woodnymph Trail
Lookout Mountain, GA 30750

Kathleen McDonough
338 Maple Street
Carlisle, MA 01741

Ellen McCormick Martens
828 Columbia Drive
Janesville, WI 53546-1722

Leslie Masters
8197 Lake Crest Drive
Ypsilanti, MI 48197

N. L. Matus
25802 South Cloverland Drive
Chandler, AZ 85248

Elaine S. Miller
1003 Indian Creek Road
Jenkintown, PA 19046

Marge Mills
P. O. Box 204
Rockport, MA 01944

Glenn Moreton
9200 Edwards Way, 1011
Adelphi, MD 20783

Shozo Nagano
39 Race Street
Jim Thorpe, PA 18229

Marsh Nelson
185 Edgemont Avenue
Vallejo, CA 94590

Bart O'Farrell
Treleague Farm
St. Keverne
Helston, Cornwall TR12 6PQ
UNITED KINGDOM

Edith Hodge Pletzner
221 Rose Street
Metuchen, NJ 08840

Nydia Preede
Box 344
Eastontown, NJ 07724

Doris Price
Rural Route 8, Box 511
Millsboro, DE 19966

Stephen Quiller
Quiller Gallery
P. O. Box 160
120 Creede Avenue
Creede, CO 81130

Dale Ratcliff
237 Western Avenue
Gloucester, MA 01930

Bill Rohan
18 Nash Hill Road
Williamsburg, MA 01096

Lois Schachter
54 Milwood Road
Glen Rock, NJ 07452

Max R. Scharf
12635 Woodygrove Court
St. Louis, MO 63146

Judith Scott
6658 South Gallup
Littleton, CO 80120

Nancy Smith
1630 Monument Avenue, #9
Richmond, VA 23220

Sandra Lee Smith
Redwood City Art Center
2902 Briarfield Avenue
Redwood City, CA 94061

William Smith
6228 Magnolia
Rowlett, TX 75088

Edith Socolow
Salt Island Studio
26 Salt Island Road
Gloucester, MA 01930

William St. George
711 Boylston Street
Boston, MA 02116

Kathy Stark
35 Milbrook Road
Nantucket, MA 02539

Judith Surowiec
2795 Ashton Tree Court
Dacula, GA 30211

Andy Syrbick
27 Clinton Street
Framingham, MA 01701-6702

Meyer Tannenbaum
235 West 71st Street, #4
New York, NY 10023

Bill Teitsworth
Rural Route 6, Box 6427
Moscow, PA 18444

Lynn Tornberg
19 Mill Street
Manchester, MA 01944

S. Webb Tregay
470 Berryman Drive
Snyder, NY 14226

Susan Lucas Updyke
10 Brentwood
Bristol, TN 37620

Lawrence Wallin
895 Toro Canyon Road
Santa Barbara, CA 93108

Betty Welch
4364 Newbury Drive
New Port Richey, FL 34652

D. Wels
1726 Second Avenue
New York, NY 10128

Marcia C. Wilhelm
364 Elm Street
Duxbury, MA 02332

Claffy Williams
220 Atlantic Avenue
Cohasset, MA 02025

Douglas Wiltrant
969 Catasauqua Road
Whitehall, PA 18052